WOBURN

HIGH SCHOOL

HISTORY, PRIDE, TRADITION

SUSAN ANN BRUNO THIFAULT

Research Editor Theresa M. Christerson

THE
History
PRESS

Published by The History Press
Charleston, SC
www.historypress.net

The cover is graced by the main 1906 building with the addition of wings that were added in 1930. The top three photos from left to right include an enthusiastic crowd at a football game from the 1960s, the beautiful majestic front door of the 1906 high school building and a group of 1950s students planning their club activities.

The back cover top image is the 1956 activities committee getting ready for a new school year. From left to right are (first row) Lewis Deluca, Myrna Masse and Joan Balestrier; (second row) Joseph Upton, Marilyn Little, Mary Danforth and Shirley Knowland; (third row) Josephine Ciampa, John Marlowe and Richard Canniff. The middle image is the tanner bull mascot created in the 1970s and a section of the school fight song. The bottom back cover image features the main entrance of the 2006 high school.

First published 2016

ISBN 978-1-5402-0022-8

Library of Congress Control Number: 2016937194

Education is the Best Wealth
Education elevates . . . It is the best wealth the parent can bequeath to his child.
Gold, and house, and lands and stocks are all of uncertain tenure,
and may soon flee the possessor;
but an education is something that is ever present,
constantly accompanying one life through,
yielding more joy and satisfaction than any amount of material possessions can.

—1865 Report of the Selectmen of the Town of Woburn

To my family, my husband, Leo, and children Kathryn, Kevin and Karen, thank you for your unconditional love, encouragement and support.

To my mother, Janet Murray Bruno, and George William Harvey, thank you for your love and always being there for me.

*To my dear friends, you are my chosen family;
I value your friendships every single day of my life.*

To those who purchased this book. Thank you very much.

Contents

Enjoy being a high school student once again.

Preface

*We become who we are due to the many opportunities
we are given with an education and a passion for learning.*
—Susan Thifault

Every journey begins with the first step, and mine began on a beautiful New England September morning with two of my best friends, Carolyn and Joanie. We walked down Montvale Avenue on our way to our very first day of high school. There was the feeling of excitement with a tinge of nervousness as we approached the school. We entered Building Eight, climbed the stairs, searched for our homerooms and began our high school careers. Entering this school would have a tremendous impact on me for the rest of my life. Now, thirty-seven years later, I walk the halls and feel blessed to know the heart and soul of this school as a student, teacher and parent.

The research and writing of this book has been a labor of love with a passion to discover the unique school history bestowed on the generations of families in Woburn. The importance of education was strongly emphasized to me at a young age due to a long line of educators in my family. The high school, in particular, has played an intricate role. My great-aunt Mary Murray was a history teacher and guidance counselor. My mother, Janet Murray Bruno, was "that typing teacher," class advisor and chairperson of the business department. The teaching profession extended to my aunt Margie Murray Landry, a former teacher at Goodyear Elementary School in Woburn; uncle Roger Landry, former principal at the Charlotte Murkland Elementary School in Lowell; and their daughter Patricia Landry Heo, who teaches at

the Malcolm White Elementary School in Woburn. Family alumni include my grandparents Charles Murray and Eleanor Daw Murray, class of 1933; their children Janet, class of 1954, and Margie, class of 1963; myself, class of 1980; and my children, Kathryn, class of 2012, Kevin, class of 2014, and Karen, class of 2015.

IMAGINE IF THESE WALLS COULD TALK

Why write a book on the high school? Simply put, it has never been done, and the school deserves to have its story told. We are living history, the connection to the past, and the high school is one of the intricate links in our lives. When the process began in 2004 for a new high school building, I became obsessed with the sentimental meaning of the 1906 building. I photographed the entire building, hoping to capture the unique character and charm that so many of us loved. I was moved to tears when the time came to say goodbye. The time seemed right in 2015; I realized the story of the school should be told. I enlisted former Woburn High teacher and my dear friend Theresa Christerson to assist with the research and editing. We reached out to alumni via e-mail, social media and newspapers to find those who were willing to share their stories with us. Many had beautiful recollections of their high school years, and we were moved to tears when we interviewed some of the oldest alumni from the 1940s. Everyone had fond memories and treasured their friendships, some that have lasted over seventy years. We spent over one year and countless hours in the school archive room sitting on the floor pouring over 160 years' worth of information. We soon realized that there could be numerous books written on athletics, activities or faculty alone. Decisions were difficult, as we wanted to capture the essence of the school. Those cherished long-ago voices of students echoed in our minds as we read articles, viewed photographs and marveled at the historical items. Every time we opened a scrapbook, history became part of the present, as the priceless mementos seemed to be waiting for someone like us to give them their due credit.

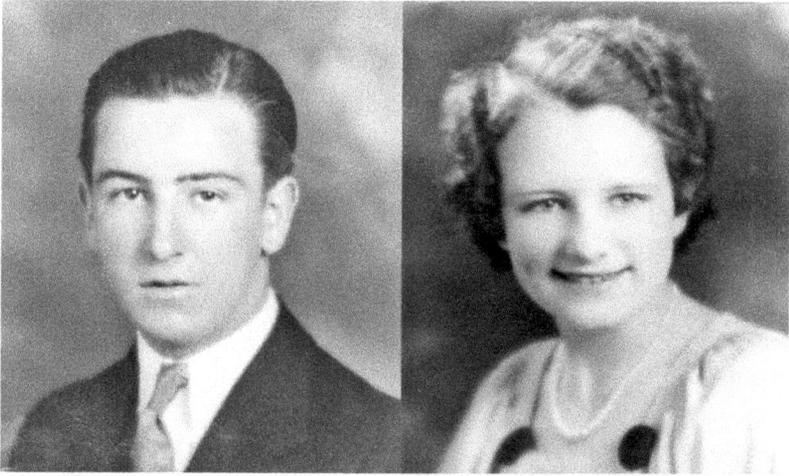

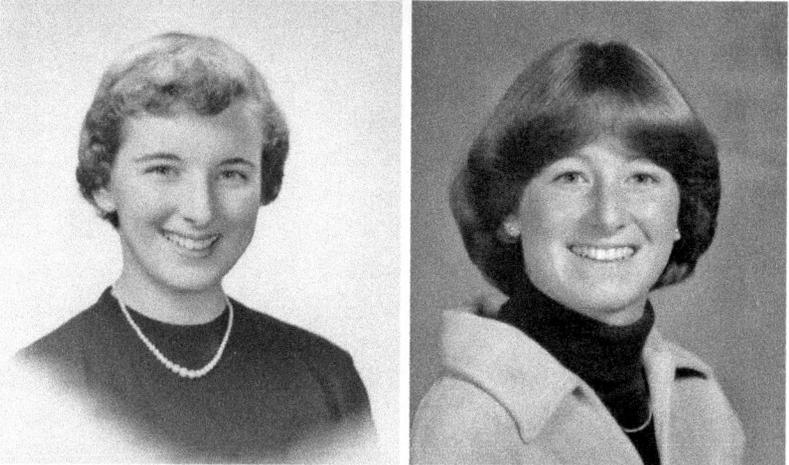

Top row: Author's grandparents Charles T. Murray and Eleanor M. Daw, class of 1933.
Middle row: Author's mother and the author, Janet E. Murray, class of 1954, and Susan A.
Bruno, class of 1980. *Bottom row*: Author's children, Kathryn E. Thifault, class of 2012;
Kevin L. Thifault, class of 2014; Karen M. Thifault, class of 2015. *Author's collection.*

Acknowledgements

This book could not have been written if I did not have the tremendous support of Theresa Christerson, who made the journey of researching, editing and selecting photographs an adventure. I am forever grateful to all the Woburn High School librarians who painstakingly archived everything from letters to graduation programs in order to preserve history. A very special thank-you to all the alumni who contributed their memories in writing and took the time to be interviewed on video. It was emotionally overwhelming reading and listening to your stories.

I received tremendous support, guidance and advice from many people and organizations. I sincerely appreciate the kindness of the following: Leon Basile, Marie Coady, Beth Hegarty, Joseph Elia, Rodney Flynn, Abby Gillis, Kathy Lucero, Sheila McElhiney, Mike Sallese, Lynn Thambash, Woburn Public Library staff, *Woburn Daily Times*, *Woburn Advocate*, Joanne Collins of the Woburn Senior Center, Barbra Graham of New Horizons for arranging resident interviews and Bob Shure, Kathy Shure and Lisa Benson of Skylight Studios, Inc. for their expert advice. A very special thank-you to Theresa Taranto and Maureen Trickett of the Woburn Memorial High School Harlow Library for assisting on research and Brian Ouellette, Jennifer Gatta, Lauren Coleman and Kristin Ahern of Woburn Public Media Center for allowing us to film interviews. I would also like to express my gratitude to the Woburn Historical Society for sponsoring this book's release event.

1

Woburn, Massachusetts

Where did you grow up? Where did you go to high school? When we meet new people for the first time, we try to make a connection because in life, it is all about connections. In this diverse world, we always seek to find a bond that is often a hometown, high school or college. If you grew up in Woburn, you are all too familiar with the pronunciation of our city name. Yes, we pronounce it "Wobin," but it really sounds like "Wooburne." According to John D. McElhiney's book *Woburn, A Past Observed*, the name actually is derived from ancient Anglo-Saxon words: "wu," "woo" or "wo" meaning tree, wood or timber and the other being "burn," "bourn" or "bourne" meaning brook. The next question we are usually asked is "Where is Woburn?" Our response? "Woburn is located approximately ten miles north of Boston, you know, right by Winchester, Burlington and Lexington."

Our home has always had blue-collar, working-class roots. It was settled by seven men from Boston's Charlestown neighborhood in 1640, incorporated as a town in 1642 and became a city in 1889. One of those seven men, Captain Edward Johnson, was regarded as the "the father of Woburn," perhaps because he seemed to stand out as the leader of the group. He eventually became the city's first mayor and was the town clerk and recorder. Johnson's descendants are thirteen and fourteen generations deep in Woburn, and many still call this city their home. There is an unspeakable bond that true Woburnites have by virtue of being born and raised here before starting families. If you moved here later in life, you can pretend to be part of that bond, but you will always be known as a carpetbagger.

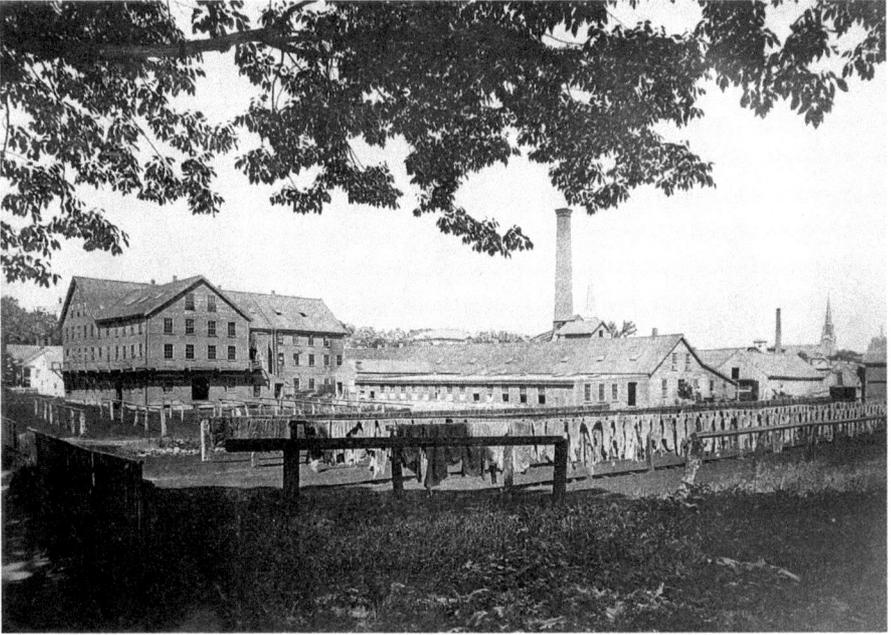

James Skinner Tannery, Green Street, Woburn, established between 1850 and 1860. *John D. McElhiney collection.*

"You're a Tanner?" Generations of students have cheered for their school and probably never realized where the name "Tanners" came from or how the bull became the mascot. According to the 1910 school archive book, it was the demand for shoe leather during the Civil War. Tanning became Woburn's principal industry, and it became "home of the tanyard." The first tannery was established in 1673, and at one time, Woburn was known to be the leading manufacturer of leather in the world—with over twenty tanning establishments.

Woburn has several historical landmarks that are valuable windows into the past. The Woburn Public Library is a National Historic Landmark designed by architect Henry H. Richardson. The Count Rumford House was the childhood home of Benjamin Thompson, soldier, inventor, statesman, scientist and physicist. The Middlesex Canal, which operated between Charlestown and Lowell from 1805 to 1856, was an engineering feat of its time and provided transportation before the railroad. The Baldwin Mansion is the site where the Baldwin Apple was developed, and 1790 House is a colonial inn and tavern that was a stop on the Underground Railroad during

the Civil War. Woburn was also home to Charles Goodyear, who discovered the vulcanization process for rubber.

Woburn is 12.9 square miles, with a population of approximately thirty-eight thousand and a school system consisting of one private school and eleven public schools—one high school, two middle schools and eight elementary schools. There are numerous athletic fields, a community ice rink, a nine-hole public golf course and Library Park recreation field. The jewel of the city is the spectacular area of Horn Pond, where legend has bestowed the names of Lake Innitou and Mount Towanda to the area. This region has a peaceful pond, hiking and walking trails and a mountain view of the city of Boston. If you happen to experience the beautiful sunsets at the pond, you will understand why we call Woburn our home.

Introduction

The adolescent memory imprints reminiscences indelibly, so it's not surprising that the most vivid memories everyone carries with them into adulthood, and the ones that stay with them throughout their life, are the ones they make in high school.
—Marie Coady

HISTORY

Everyone has a story: a story of how they grew up, where they lived and what school they attended. Woburn High School has a story, too, one that is rich in history, pride and tradition. This story is about a school that is held in high respects and beloved by those who have walked through its doors over the course of its 164-year history. The hallways still echo with the voices of alumni past, and students continue to learn the value of an education. It is where students become part of a miniature community and their hearts pulse with experiences of friendships, dreams, hopes, trials and tribulations. It is here that they will know more people by their first name than at any other time in their lives. It is when they accept their diplomas that they become part of history.

Pride

The first mention of "orange and black" dates back to the school newspaper in the early 1910s. It was not until the 1940s that the "Tanner" was mentioned, and in the 1970s the bull appeared, making a

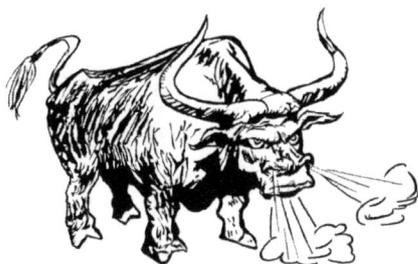

"TANNER PRIDE"

The tanner bull mascot for Woburn High School created in the 1970s. *Woburn Memorial High School archive collection.*

fierce impact as school mascot. The school's motto, "Tanner Pride," was coined in 1973 by football coach Peter Sullivan. Even before this motto, generations felt school pride and value it today, as alumni return in support of academics, activities or athletics. This pride has been woven into the fabric of their lives, and they wear it as a badge of honor. Many are proud to say they bleed "black and orange": it is part of who they are today.

Tradition

"It's tradition"—two simple words that have been whispered by faculty and upperclassmen to the incoming students every year. Traditions blend a school of individual students, staff and families into one community, and that becomes a significant part of the school's culture. The preservation of traditions is perhaps alumni's way of keeping careful watch over everyone to make sure they are embracing history. The school archive books gave us a peek into how traditions began and how some continue today. Traditions are the torches that are passed from one generation to another, allowing the future to understand the past.

This 1887 statement from the annual reports seems quite appropriate today, as we still have many multigenerational students and over half of the faculty are alumni:

The high school has always been dear to the popular heart, and has absorbed a very large share of the attention which the public vouchsafe to education. It is not unfitting that this should be the case, since so many citizens of the town received some portion of their education within its walls. It is

especially interesting to note the fact that, besides sending a large number of its graduates into the various professions and the business world, it has supplied over eighty percent of the teaching force employed here. The influence which this institution has exerted upon the community in this one particular is almost incalculable, and would, alone, simply repay the care with which it has been cherished and sustained.

3

Those Who Lead

And might I suggest, that some day many years from now, a future generation of Woburnites will pause, and look back at all of us, the present generation, and say that we knew that too and that we acted accordingly.
—John D. McElhiney, Class of 1973

There have only been thirteen principals, seven leading the administration team in the first forty-seven years alone. The longest administration record was the thirty-five-year reign of Orel Bean, followed by the twenty-nine-year management of Henry Blake. Leadership skills were of the utmost importance when the principal was selected, and the outcome was evident, as there was little turnover at the top. Their management styles varied, but differences aside, each one understood the importance of the school and the value of an education.

1852–1862: Mr. William A. Stone	1908–1916: Mr. George W. Low
1862–1871: Mr. Thomas Emerson	1916–1951: Mr. Orel M. Bean
1871–1887: Mr. James J. Hanson	1951–1980: Mr. Henry D. Blake
1887–1890: Mr. Herbert B. Dow	1980–1993: Mr. James J. Foley
1890–1892: Mr. Samuel W. Mendum	1993–2009: Mr. Robert C. Norton
1892–1893: Mr. Louis H.W. French	2009–2016: Mr. Joseph L. Finigan
1893–1908: Mr. L. Herbert Owen	2016– : Ms. Jessica Callanan

4

The Process

There is a process for everything in life. This process contains a series of actions or steps that we acquire in order to achieve a particular goal. These actions include researching, evaluating and planning until the procedure is completed and we feel as though we have achieved our goals. The process of establishing a high school is no different from any other course of action. There were obvious needs for an institution of higher education, concerns over the location of the high school, differences of opinions and even fines if the town of Woburn did not take action. When everything was said and done, the community and its leaders stepped forward to complete the process every single time over the past 164 years. A high school embodies all the hopes and dreams of the community. Outsiders may say it is just a building, a place where students go to learn. Yet for this particular high school, that was not the case—just ask the generations of families who attended and called Woburn their home. The hands of the laborers who worked mixing cement, turning it in a rhythmic pattern, knew this. The masons that painstakingly placed brick by brick to form a school building understood this. The community worked step by step through the process of providing excellent education for its children. The importance of educating students would forever shape the lives of the future of this community.

According to the 1875 annual school report, the first mention of a high school concept was not until 1839, when a committee of nine was chosen and instructed to have a report at a future meeting. Due to the influx of immigrants and the overcrowding of the town's grammar- and

intermediate-level schools, plans needed to be set forth for some type of higher education. As it was, each district had to hire its own teachers and pay for school supplies. If children wanted to further their education beyond the age of twelve or thirteen, they would have to attend the town's private school, Warren Academy. Many families did not have the means to send their children to this school, so in retrospect, they could not continue their education. The annual school report of 1872 reported that $2,500 was raised for a school with an additional $500 added each year in 1846, 1847, 1848 and 1849. Meanwhile, the matter of a high school was introduced again, and for several years after the school was organized, appropriations were made for $1,200 to $1,800 yearly for its support. According to the 1851 annual school report, District One principal A.J. Burbank noted, "There seems to be some kind of want of a high school for pupils so they could have a more advanced range of studies and the pursuit of studies which should be strictly confined to a high school."

The community seemed content with the schoolhouses and the established educational process until Director Horace Mann of the Massachusetts State Board of Education notified the town. Mann, later known as the father of education, was not pleased with the educational situation. In the annual school committee report of 1851, it was noted that "a genuine high school seems to have been thought of, as something both desirable and possible for the first time." The importance of education was realized by the school committee prior to public opinion. It was stated, "The town had a population which already rendered it liable to prosecution for neglecting to provide a high school, they ventured cautiously in their annual report to recommend immediate attention to the subject."

A great number of the citizens were preoccupied with the strong opinion that nothing good would result from establishing a high school. The demands for a high school started to gain momentum when the department of education continued to put pressure on the town to pursue further education. The annual school report of 1851 noted that the state board threatened the town with fines if it did not have a way to educate youth of secondary-school age. The board noted that the town had complied with the requisition of the law for the primary and grammar schools but not for a public high school. The report recorded:

We mean the establishment of a high school. It is unnecessary for your committee to refer to the well known fact, that this town is legally required to have such a school. But the very thought that Woburn is to be compelled

by law, to do what is so universally admitted to be her interest and duty to do should cause the face of every citizen to mantle with the blush of honest shame. We should be mortified indeed, to have the intelligence go abroad, that the town has been fined the sum of sixty-four hundred dollars or twice the largest appropriation ever made for school purpose, because of its neglect to establish a high school. Your committee willing to hear the odium consequent upon such neglect but that, by timely effort in the proper direction, they will cut off all occasion of reproach.

Opinions had changed by March 1852, when a positive reception was given to an agent of the board of education and the committee representing each of the districts in the town. They took the matter into consideration even though there was an increasing negative opinion from those who did not want a high school. The 1852 annual school report stated it was of absolute necessity that the town establish one. The committee finally furnished evidence that "Woburn would engage with hearty zeal in the good work and that they shall soon have its successful operation to school of the highest order established on the finest basis." A committee was chosen, and at a later meeting on April 5, 1852, the subject of the high school was taken into consideration. The committee voted and approved the following process: the town immediately had to take the proper steps to establish a high school, the sum of $1,200 would be designated for the above recommendation and a committee should be formed to acquire a suitable room and a teacher for the school.

THE FIRST CLASSES

The annual school reports of 1845 to 1869 noted that on April 26, 1852, several rooms were hired in the Knight Building on Main Street, between Walnut and Everett Streets in Woburn Center. The rooms were leased and constructed for the temporary school accommodations since only $1,200 had been designated by the committee for defraying the whole expense of the enterprise. Stephen Knight leased the rooms for $100 per annum for one year. The committee had an option of having the lease renewed if the town desired for three years longer, which was appropriate for a four-year high school education. The committee also realized the importance of ventilation, as it was stated in an October 11, 1852 report, "I herby consent the town of Woburn, the lessees of the room in 'Knight's Building' may cut a hole through

discuss other options. Meanwhile, in 1924, the tract of land in the rear of the high school that was used as a cow pasture in the summer and flooded to form a skating rink in the winter was now being contested by the community. This swampy area was surrounded by hills and, in the eyes of most people, was an added expense to the city's debt. The football and baseball teams played at Library Park, which was also swampy land. Mayor Golden took the first step toward a new field, along with the help of the city council, when they obtained a sum of money to remove the side of a hill in the rear of the high school. The leveled piece of land was now large enough for a football field. The following year, the city council voted to have the field finished, and the high school teams played on the field known as the "Woburn cow pasture." However, the rest of the field effort was lost amid the tremendous crisis that the city faced with the overcrowding of the high school.

THE NEW WINGS

After years of difficult decisions, the process of building the additions began in 1929. The final decision was to have one of the wings house the junior high and the other house the senior high, with the main 1906 building designated for administration offices. Geraldine Spencer, class of 1929, remembered:

> *The school days were 1:30 p.m. to 5:00 p.m. due to overcrowding. During the time our new high school was being built, the accompanying noises gave many of us excuses for inattention. Several of us came early to watch the fascinating construction work. Some in fact gazed so long that they ceased coming to school after the first quarter and applied to the contractor for employment.*

The main 1906 building became the central unit of the new structure and was completely remodeled. The center of the rear of the present building was reconstructed, and a large assembly hall with a seating capacity of up to 1,200 was added. This beautiful hall was arranged in a theater plan with a general use for community, as well as school, purposes. A cafeteria, classrooms and two wings were located beneath the assembly hall. One of the wings contained shops, and the other doubled as a gymnasium with a gallery for spectators along one side, along with locker and shower rooms for athletic teams. The maximum capacity of the new facility was estimated at

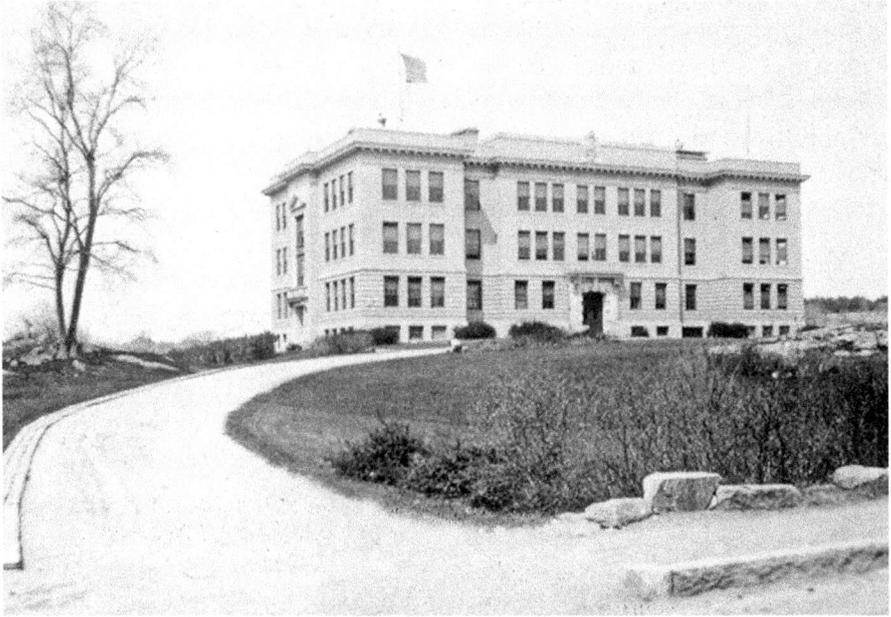

Above: The new 1906 high
school building located
at 88 Montvale Avenue.
*Woburn Memorial High School
archive collection.*

Right: The beautiful,
majestic front door of the
1906 high school building.
*Woburn Memorial High School
archive collection.*

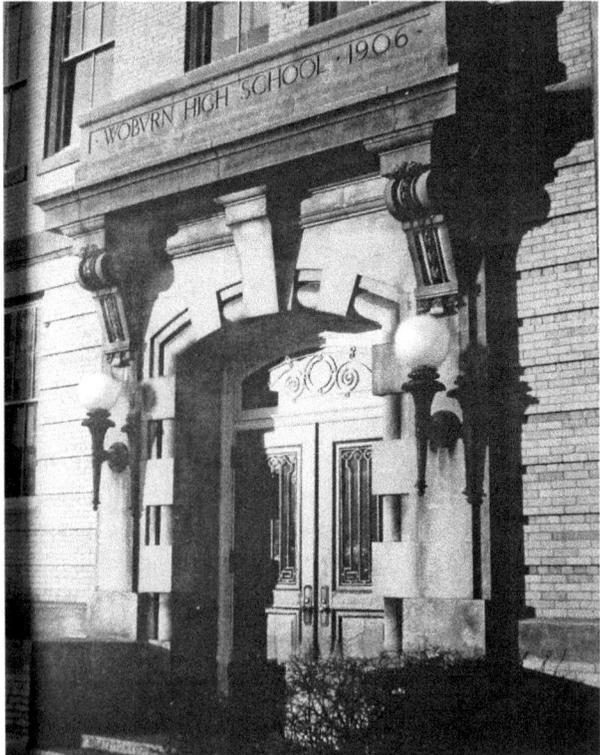

with a large fan that helped form part of the ventilation, which forced already warmed air into the schoolroom. Ventilation was important to the new building due to the deplorable conditions that existed in the previous buildings. The building was attractive, with beautiful woodwork, and enhanced with generous gifts of pictures and casts presented by alumni classes, as well as members of the community. The majestic front entrance with "Woburn High School 1906" chiseled into the parapet stone piece complemented the ornate stone archway and symbolized a new gateway for education.

It would be a scant seven years later, in July 1913, when the building came near its utmost capacity. Once again, the increase of students played a role in acquiring more space. The school report mentioned that the student population had grown from 280 to 450 students since 1906. The school had doubled in size, and there was a need for a larger lunchroom, gymnasium and additional classrooms. The city was confronted with a serious accommodation problem. Mayor Bernard Golden pushed for a new high school in his inaugural address, stating that the city was strong financially, with the borrowing capacity of $135,000. In the meantime, the city provided funds for a portable with two rooms that housed 60 pupils in 1922. The portable was purchased from St. Charles Church and added to the rear of the Montvale Avenue building. The student-teacher ratio hit an all-time high of 30 to 40 pupils to 1 teacher in each class. Classes were taught in the portable until it was destroyed by a major hurricane in 1922. In 1926, first-year students had to take all of their classes in the afternoon, as the school adopted a double-session schedule. At the same time, the country saw a rapid development of the junior high concept, which was a relatively new development in Massachusetts. This concept created the need for a separate school that bridged the gap between elementary and high school. Woburn was faced with difficult decisions: how to determine to what extent it could facilitate a new junior high school and deal with the soaring high school numbers. This plan would change before the final buildings were added.

The educational demands across the country began to change, and the high school needed to provide for the development of physical training, commercial studies, manual training and domestic science. The 1923 Woburn School Report noted that the school board entertained two plans for the school system. Plan A was to build a new senior high school and plan B to use the present high school building as a junior high or elementary building. After much debate, the best alternative was to use the present building as a senior high and have the junior high be located at the Hanson and Cummings Schools. This decision would soon change, as the committee continued to

will help to improve its moral and social conditions and to enhance its material prosperity. I know of no investment that promises a better return to any municipality than a judicious expenditure of the public money in the erection of substantial, commodious and healthful school buildings.

On April 12, 1900, the city council appropriated $90,000 for the purchase of a site, production and furnishings for a new high school building. During the June 21, 1900 city council meeting, a portion of the Dow Farm was unanimously approved as the new location. Dow Farm was located on Montvale Avenue, comprised 34.67 acres of land and was generally considered a perfect location. Emerson remarked, "There is a strong value of holding this property for public purposes due to the importance of having so many acres of land near the center of the city." According to John D. McElhiney's book *Woburn, A Past Observed,* by the time George Clapp was appointed superintendent, he had to tackle the overcrowding of schools on his first day on the job. Clapp suggested that the city purchase extra land at Dow Farm for future space for athletic fields. This foresight played an enormous role in the school's scope over the years. During the school committee meeting on August 12, 1903, the additional land was approved and purchased by the city for $18,000. Plans were set forth and communicated to the city council with the recommendation of constructing a new building and having the old building used for lower grades. Unfortunately, no other steps were taken toward the production of the building, even though the school committee members understood the urgency for a new high school building due to the congested conditions of the lower schools and the inadequate accommodations at the high school.

The annual school report of 1897 noted that the high school on Main Street had 300 pupils in a building that was originally planned for 250. The time had come to begin plans for the long-delayed high school building project, but two years passed and no progress was made. In 1905, workers finally started to lay the foundation, but the work of erecting the building was delayed until April 1, 1906, when the foundation was completed. The dedication exercises on May 15, 1907, drew a large crowd from the community, beaming with pride at their new $150,000 building. The new building allowed students to have greater opportunities for a curriculum that reflected the time. The 1906 Woburn School Report described the building: "The new building is of mottled grade brick, one hundred forty by eighty feet wide, planned to accommodate four hundred fifty to five hundred pupils." The building was heated by direct and indirect steam

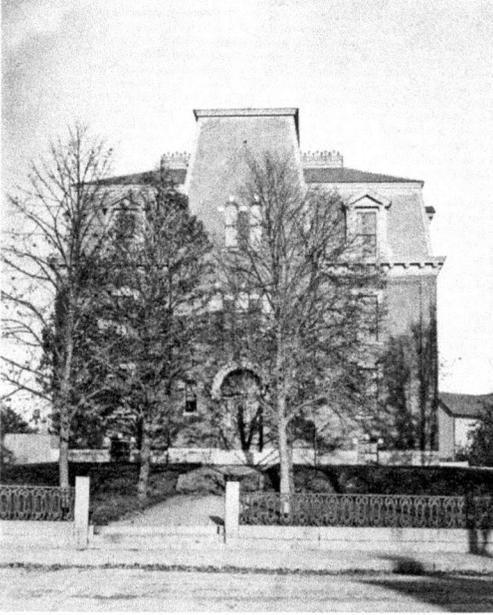

The brick addition added in 1873 to the original high school building located at 501 Main Street. *Woburn Memorial High School archive collection.*

accommodations for curriculum, attendance, library and chemical labs. The building had to be enlarged at once, or the education of the students would suffer. The town appropriated $15,000 for a brick-front addition that contained a spacious hall and more rooms. The 1896 Woburn School Report stated, "There is no doubt among the community that there are pupils in the high school, who for one reason or another are unable to take all the full courses of study without injury to their health due to conditions of the building." The enrollment at this time was sixty-one students with nine teachers. In 1897, Superintendent Thomas Emerson recommended that the town look for a new location and construct a building. The school committee requested that the city council appropriate funds from 1898 to 1900 for a new site and building.

A NEW LOCATION

Superintendent Emerson stated in the 1897 Woburn School Report:

It was the right time to greatly improve the city's educational advantages by means of these we may hope to attract to our city a class of people that

the side of said building for a pipe for letting in cold air into the high school room. Signed Stephen F. Knight."

On September 6, 1852, a world of opportunity began when Master William A. Stone and students started the first day of high school classes. The first class was held with thirty-four scholars admitted; all but four of the students were girls. The school became the pride of the town, even though some community members thought money was being spent as an impulse action. The 1869 annual school report noted, "It has been proved to be a necessity and it is now seen to be and is believed by the great mass of our citizens to furnish the way and means of the best education of our children, and to be the only true republican method of educating them for the performance of the practical duties of life."

The Knight Building on Main Street, where the first high school classes were held. *John D. McElhiney collection.*

A NEW BUILDING

Two years later, in 1854, the school had outgrown the limits of these rooms, and the town decided to build a high school while classes were still being conducted at the Knight Building. A new wooden schoolhouse was built at 501 Main Street at an expense of $11,701. By 1873, the wooden building had served its purpose, and immediate attention was needed due to insufficient

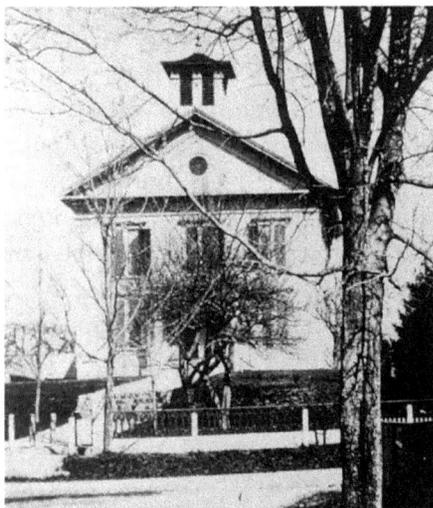

The original high school building, located at 501 Main Street. *John D. McElhiney collection.*

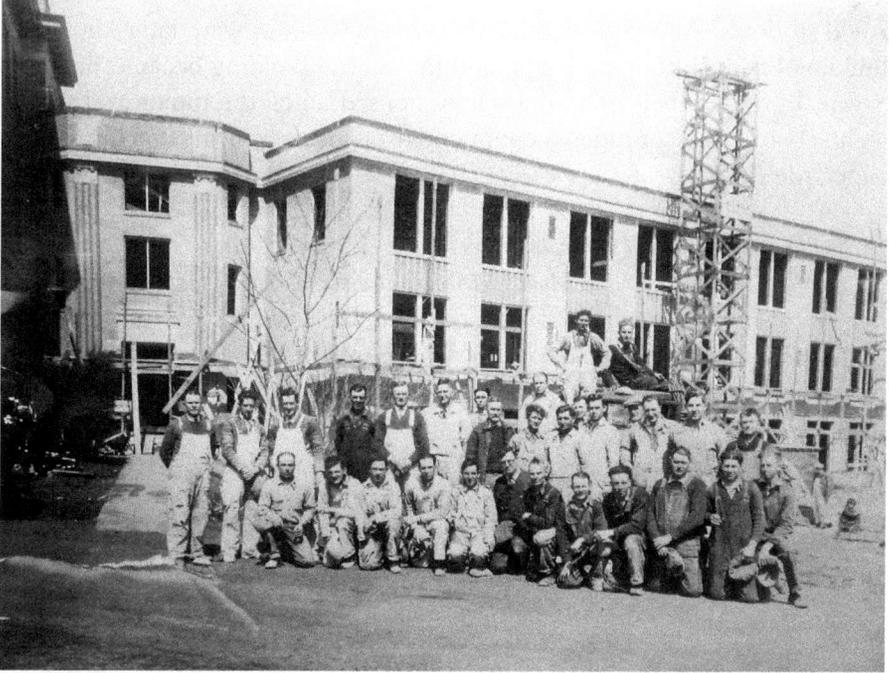

The proud construction crew that built the addition wings in 1929–30. *Woburn Memorial High School archive collection.*

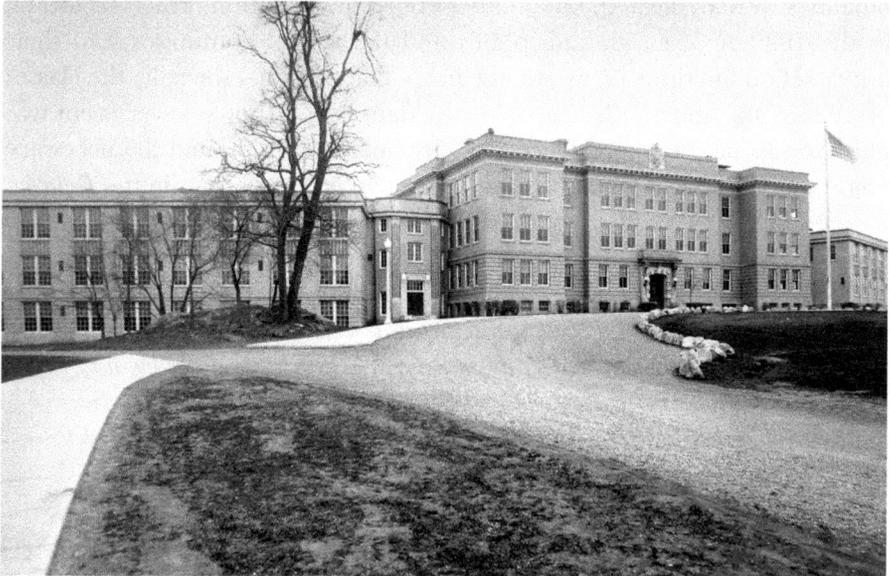

The completed addition wings of Buildings Six and Eight. *Woburn Memorial High School archive collection.*

2,000 students. At a cost of $650,000, the new wings were later known as Building Six and Building Eight, and the central building became Building Seven. In September 1930, the school housed all of the junior and senior high school classes. Students commented on the new wings in the school paper, the *Reflector*.

> To automobilists and casual visitors to the city of Woburn as they speed along Salem Street and Montvale Avenue it must be evident that Woburn is sparing no expense to give her sons and daughters every advantage in education, a worthy aim second to none in civic and national importance. Clothes may not make the man nor the buildings a school but they certainly do help we all agree.

On November 11, 1930, the city christened a new moment in education with the dedication of the new wings. Over the next thirty years, these buildings served the educational needs of the community.

AN ATHLETIC FIELD

One would believe that the citizens of Woburn could relax as soon as the buildings were dedicated, but another enormous situation arose. According to the 1929 *Reflector*, alumni, pupils and the school committee had their minds set on building a new athletic field. The alumni, especially the classes of 1926, 1927 and 1928, staged parties, dances and shows—every cent was put aside to start the new field. The city finally appropriated the necessary funds, and work started on the new field, as noted by students in the *Reflector*:

> In preparation for the dedication of the new field there was a grand outpouring of both young and old who witnessed workmen putting the finishing touches on the gridiron in preparation for the big game. Students rehearsed songs and cheers in the monster cheering section of the big new grandstand. The school band will be ready to render a snappy musical program between the halves. The grandstand was a blaze of color with orange and black predominating. The field was finished in September, just in time for the first home football game. The dedication of the new field was a gala affair, with over five thousand attending the first football game of the season. The athletic field was one of the finest schoolboy parks in the state, with parking for two hundred fifty automobiles.

ADDITIONAL BUILDINGS

The 1960 school archive book noted that in September 1959 the school committee requested that with new educational specifications the new buildings needed to be equipped in order to prepare students for college and the real world. The population had increased, and decisions were made to construct additional buildings on the land to the left of the 1906 building. Buildings One, Two, Three, Four and Five were constructed to include a library, cafeteria, little theater, music suite, auditorium, industrial arts area, science rooms and two gymnasiums. The approximate costs of all the buildings was $3.3 million. The junior high students who were located in the building were moved to East Junior High, now known as Kennedy Middle School, on Middle Street. In the daily bulletin, Principal Henry Blake stated, "The most important development of 1964 was operations of the new wings which relieved a greatly overcrowded condition." There were nine separate buildings to patrol, 1,800 pupils and seven and a half acres of floor space.

Due to safety concerns, a decision was made to close the fourth floor of the 1906 building. By the late 1970s, the building capacity had swelled to an all-time high, and the school housed over 2,100 students. The classes of 1976 and 1977 were among the largest to ever graduate, with over 700 students in each class. The increased capacity took a negative effect on the overall maintenance of the buildings, and over the next ten to fifteen years, the buildings started to become inadequate due to wear, tear and age. When a new middle school concept was established in 1988, replacing the

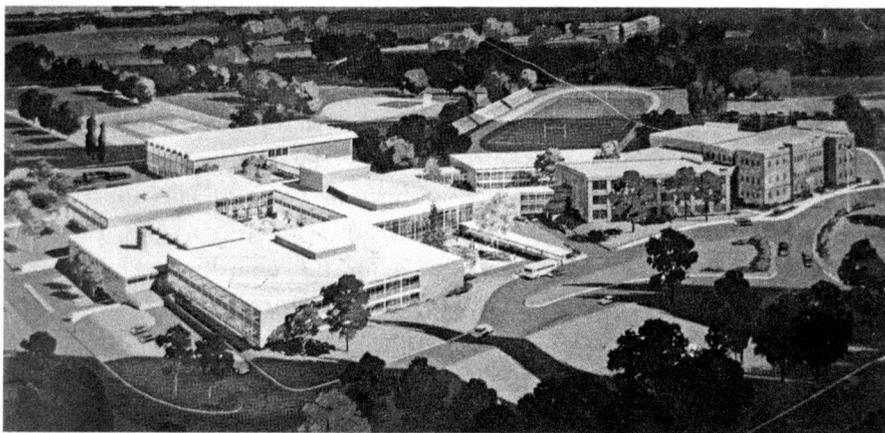

Artist's rendering of the new buildings that would be completed by 1964. *Woburn Memorial High School archive collection.*

junior high concept, ninth graders were moved back to Montvale Avenue, beginning a four-year concept of high school.

The advancement of technology in the late 1980s and early 1990s influenced the educational needs of the students. As students began to rely on technology for information, the monumental wiring and cabling task for infrastructure and the lack of designated computer rooms became a hurdle for the administration. The buildings were in dire need of repair, still heated by old furnaces, not accessible to those with disabilities and lacking central air. They had seen their share of temperature changes, leaking roofs, cracked floor tiles and insufficient classroom space. It was increasingly evident that the buildings could not be adequately adapted to the new technological age.

A New Decade, a New School Building

By the late 1990s and the beginning of the new millennium, the accreditation committee from the New England Association of School and Colleges had placed the school on probation for the poor conditions of its facilities. In the spring of 2001, Mayor John Curran, class of 1984, formed a grass-roots campaign committee called Woburn WINS (Woburn in Need of Schools) to support the debt exclusion override proposal for the building of a new high school and a new Malcolm White Elementary School. This committee consisted of over one hundred citizens who campaigned for many months, informing the community of the importance of this override. Mayor Curran and school officials held public forums around the city to educate the community on the importance of new school buildings. On June 8, 2002, a beautifully sunny day, the citizens of Woburn voted in favor of the override by an almost two-to-one margin. This historic vote changed the face of education in the city once again. Instead of separate voting stations around the city, the voting took place at one appropriate location: Woburn High School. On April 3, 2004, an overcast New England spring day, ground-breaking ceremonies for the new high school were held. Principal Robert Norton, Mayor John Curran, Superintendent Dr. Carl Batchelder, school committee members and city officials addressed a crowd of teachers, students and community members on the momentous occasion. On June 1, 2004, a ceremony was held to rename the high school Woburn Memorial High School in recognition of veterans who have fought and died for their country. The school committee had voted on the

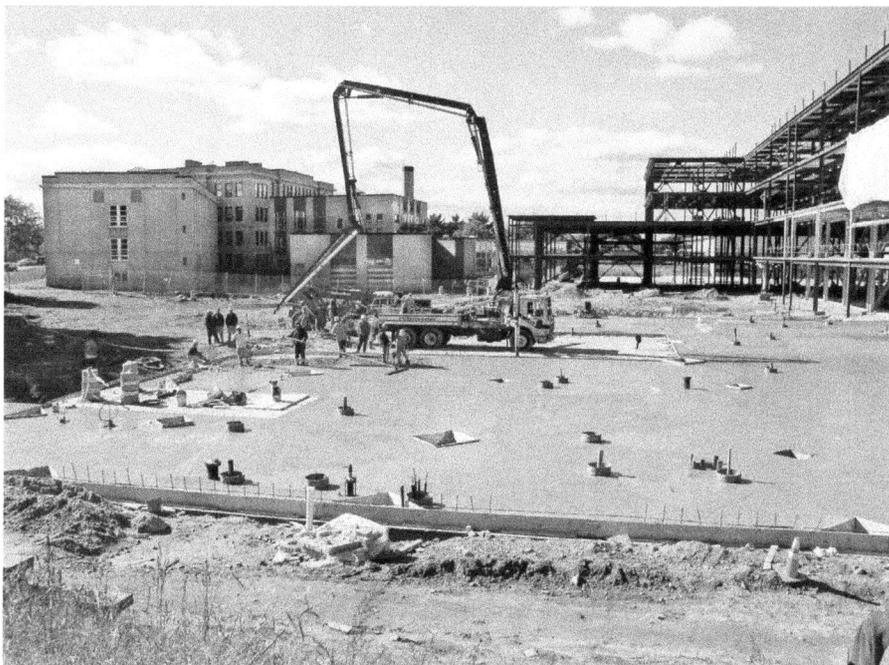

Construction of the new school located directly behind the main 1906 high school building. *Author's collection.*

name change previously, on October 23, 2003. Over the next two years, construction continued behind the old school on the Connolly Stadium field while classes were held in the original buildings. Students and staff witnessed history from their classroom windows as the building process began. Construction workers poured cement for the foundation, erected steel beams and put up walls in order for the masons to place one red brick at a time, adding the final touches just as the previous masons had done over one hundred years ago.

A new school bell rang on September 7, 2006, as Woburn Memorial High School opened its doors and welcomed another generation of students. The students and staff entered the building through the back entrance for one year, as demolition of the old school took place out front. The campus cost approximately $70 million, which included the new state-of-the-art school and fields. The school has a spacious foyer, a large gymnasium, a cafeteria, a seven-hundred-seat auditorium and classrooms equipped with SMART Boards, computers and projectors. The school is an environmentally friendly "green school" using filtered rain water, a sensory lighting system,

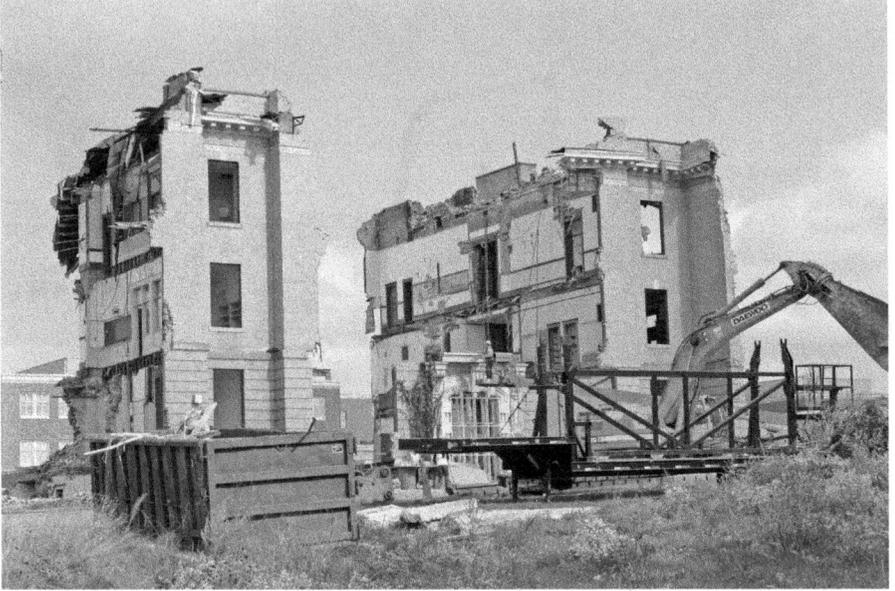

The final section of the 1906 building coming down. The front archway stones were saved and are displayed at the 2006 high school building. *Courtesy of Brian Ouellete.*

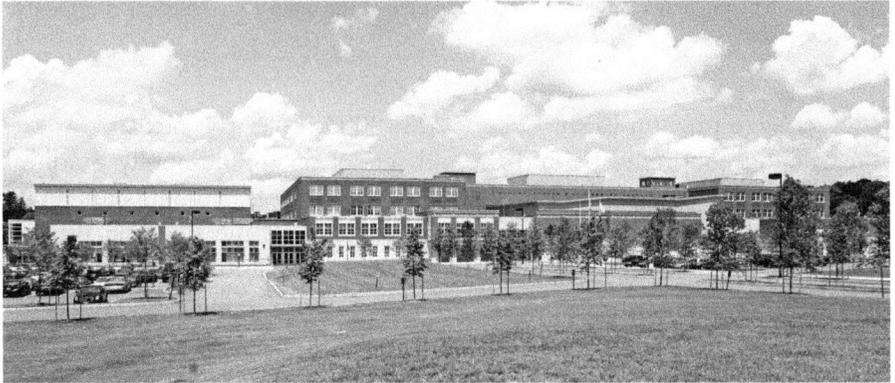

The beautiful new state-of-the-art 2006 Woburn Memorial High School building. *Courtesy of Gordon Brown Photography.*

a computer-controlled HVAC system and a security system that includes cameras throughout the school campus. The community watched the demolition of the 1906 building with sentimental eyes, and when the final section was knocked over, heavy hearts fell with it. Even though they were heartbroken for the loss of the school, the community looked forward with excitement for a new building.

The remaining areas of parking, landscaping, stadium, press box, ball field and two synthetic turf fields were completed in various stages over the next couple of years. In November 2007, the New England Association of Schools and Colleges conducted its evaluation of the new building, and in January 2008 Woburn Memorial High was officially accredited and taken off probation. The accreditation committee was thrilled that the citizens of Woburn provided a first-class educational facility for its students and community.

THE FINISHING TOUCHES

Today, when you view the front door of the new building, you will see the same ornate torch lights that graced the original 1906 building. Stepping inside, welcoming you, are the 1920s art deco glass-plated lights suspended above the main foyer that were originally located in the old auditorium. As you glance around the main foyer and auditorium, the unique Corinthian columns, reliefs, statues and friezes adorn the area just as they did in the old building. Each piece was restored and installed under the direction of Robert Shure of Skylight Studios. The wooden fireplace mantel that was located in the 1906 principal's office was given a new home in the main office, complementing the six balcony seats from the old auditorium.

In June 2007, class of 1980 members Susan Bruno Thifault, Joanie Upton Gorman and Robert Rafferty brought their original class gift sign back home and installed it at the Salem Street entrance. In the spring of 2008, John Flaherty, class of 1974, donated $150,000 for the installation of tennis courts dedicated to former vice principal and football coach James Brennan. Flaherty made the donation after reading a summer-long letter to the editor, grass-roots campaign by Susan Thifault. Thomas "Tucker" Quinn, class of 1960 and deputy superintendent of the Woburn Public Works Department, stored many of the monuments and stonework from the original school. Susan Thifault worked with Tucker over the next several years to bring all the original stonework home to the school as class gifts. In January 2010, the stone city seal of Woburn, which was located above the 1906 main entrance, was placed in the stadium courtyard as a gift of the classes of 2010 and 2011. The chiseled Woburn High 1906 main front door stonework was placed in front of the athletic building entrance as a gift of the class of 2012. By 2012, the original wooden main entrance sign needed to be repaired,

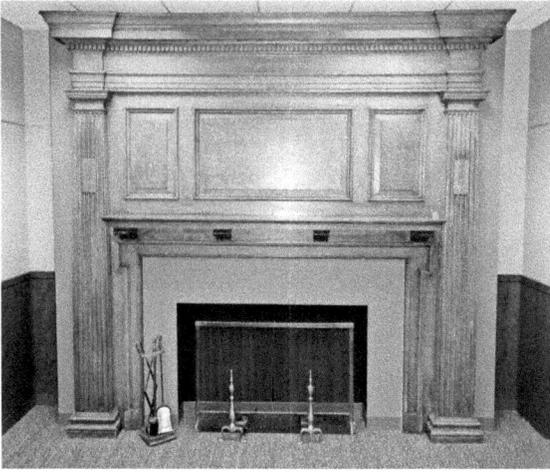

Above: Main front entrance granite sign gifted by the classes of 1950, 1953, 1954, 1955, 1956, 1958, 1961, 1963, 1964, 1965, 1970, 1978, 1979, 1980, 1981, 1987, 1989, 1995, 1998, 2008 and 2010. *Photograph by Joe Brown.*

Left: The wooden fireplace mantel from the principal's office of the 1906 building that is now located in the main office of the new 2006 high school building. *Author's collection.*

so Susan Thifault conducted a fundraising campaign to purchase a new granite main entrance sign, which was installed at the front of the school on Montvale Avenue. The $6,000 sign was a gift from twenty-one alumni classes and stands as testament to those alumni who continue to call the high school their home. In June 2013, the granite Connolly Memorial, which was located at the original stadium, was placed by the new stadium as a gift of the class of 2013. The stones from the 1906 archway entrance were placed on the grassy hill in front of the school as an outdoor classroom and named the "Stones of History" as a gift of the classes of 2014 and 2015. This process has allowed the community to reach its goal of providing for the educational needs of the community, and today, students have a building that reflects the history, pride and tradition of those who came before them.

Welcome to Woburn Memorial High School.

5

1852–1899

Taking the First Step, Meeting Educational Needs

A school is in some respects like a family,
in some respects it is like the community.
—1875 Annual School Report

The world around us has changed; students think and learn differently,
but the basic concept of acquiring an education has remained the same.
The knowledge one attains has been curated by the administration and
teachers who have dedicated themselves to shaping young minds for the
future. We become who we are through the many opportunities we are
given with an education. In this extensive span of forty-seven years, we
discover how it all began.

The 1850s were known as the Civil War era due to the issue of slavery and
the differences between the North and South. The 1860s brought a turbulent
decade that transformed the country through war. The 1870s began the
Reconstruction era, and the North changed as women entered the workforce
as factory workers, teachers and domestic servants and children worked in
the textile mills. The staples of the country were the railroad, manufacturing,
mining and finance industries. By the mid-1890s, the economy had weakened,
and the country was knocked into a severe recession, with many middle- and
working-class men losing jobs. The gap between the wealthy and the poor
widened, and the country witnessed unions campaigning for shorter workdays,
child labor laws, prohibition and women's suffrage.

According to the book *Woburn, A Past Observed* by John D. McElhiney, the
modern history of Woburn began in the 1850s: "It was a boomtown in

Woburn as the decade saw a population growth that would be unmatched in percentage terms. It was also a decade of many firsts: high school, library, fire department, newspaper, and commercial banks." The town expanded its resources with the North Woburn Railroad in 1866, public telephone usage in 1882, electric lights in 1885 and free post office delivery in 1888. In 1892, Woburn celebrated its 250th anniversary, and the population reached fourteen thousand. The city boasted 197 streets and about sixty-three miles of roadway. Due to this explosive growth, the town was incorporated as a city in 1889.

FACULTY AND STUDENTS

The faculty of the school consisted of a master (principal) and submasters (principal assistants). During its first forty-seven years, the school was led by seven principals: William A. Stone, Thomas Emerson, James J. Hanson, Herbert B. Dow, Samuel W. Mendum, Louis H.W. French and L. Herbert Owen. All masters and submasters taught classes while performing administrative duties.

Before the first school bell rang, the school committee had an important duty to complete: selecting an appropriate person to take charge of the school. The 1852 school committee report noted, "It was of the highest importance that the school should be placed under the care of a teacher of gentlemanly deportment, of high moral principles and well qualified by the literary, social and moral habits of his pupils. Among other applicants for the situation of principal was William Stone. He came well recommended as a gentlemen

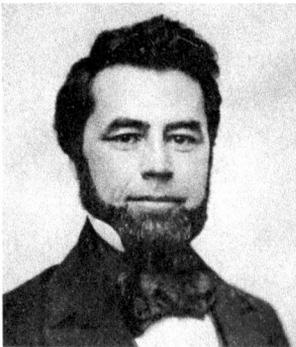

William A. Stone, first principal of Woburn High School. *Woburn Memorial High School archive collection.*

and his reputation as teacher at Winchester High School." Master Stone took great care of the school as an efficient and accomplished master and teacher. At his side were assistants Susan Edgell and Florence Holden. Stone resigned after ten years, and a young man named Thomas Emerson became master in 1862. Emerson was born in Woburn, attended Warren Academy and was a graduate of Harvard University. Emerson later became the first superintendent of Woburn Public Schools and held these two positions until he resigned to be superintendent in Newton.

James J. Hanson became the third master in 1871 and had such an impact on education that

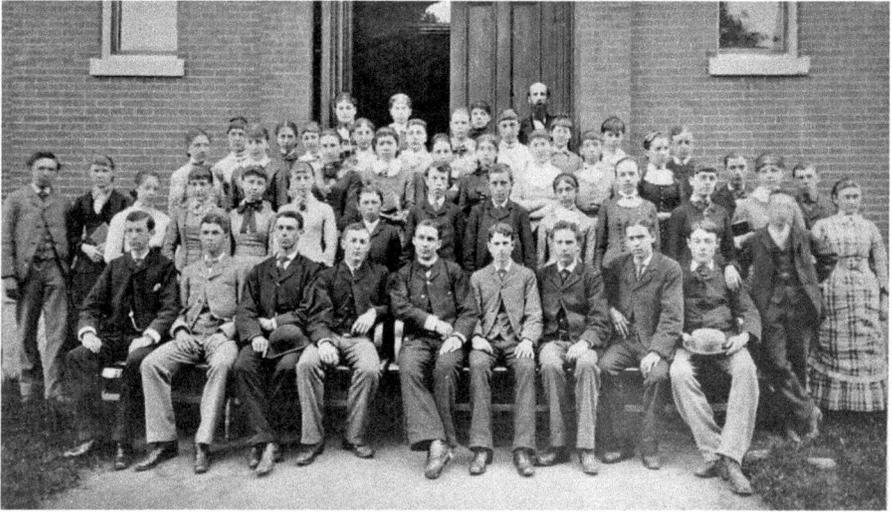

Principal James J. Hanson with the class of 1885 in front of the high school on Main Street. *Woburn Memorial High School archive collection.*

Principal Samuel W. Mendum with the class of 1891–92 in front of the high school on Main Street. *Woburn Memorial High School archive collection.*

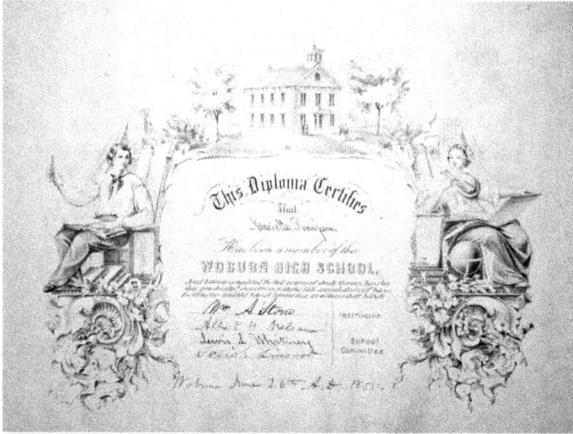

Mariette Thompson's 1855 diploma. She became the first graduate of the school to serve as one of its teachers. *Woburn Memorial High School archive collection.*

the Hanson School was named after him. Hanson departed in 1887 and went on to have a successful career in the publishing field. The next master was Herbert B. Dow, who was born in Woburn, graduated from Woburn High in 1874 and had a degree from Harvard. He resigned after three years to take a position with the Mutual Life Insurance Company. Samuel W. Mendum, a Tufts University graduate and an able, faithful instructor, was chosen to replace Dow in 1890. He resigned after two years to study law, and Louis French, submaster from Lawrence High School, began as master in 1892. But after one year, French departed and L. Herbert Owen, a Colby College graduate, became the next principal and made the move into the new building on Montvale Avenue.

Mariette Thompson, a member of the first graduating class, returned in the spring of 1856 to teach Latin. She became the first graduate of the school to serve as one of its teachers. Little did she know that she began the trend of alumni returning to Woburn High to teach.

ACADEMICS

In order to establish a school, there had to be a proper basis and understanding of the needs and qualifications of the pupils and teaching staff. One of the most important and difficult items to deal with was the length of the term of study. This included the branches, qualifications for admission, means of examining the candidates and finding efficient and competent teachers. According to the school report of 1852, the school committee decided that the term of study should be three years, which was

widely adopted in other places. This course of study allowed the pupils to investigate different career avenues. They also suggested courses in algebra, arithmetic, English, analysis, history, rhetoric, intellectual philosophy and physiology, similar to the arrangement in colleges. The length of the school term was twenty-eight weeks in 1852 and seemed justified for students to obtain sufficient knowledge of the branches that were pursued at a high school level. The qualifications for admission had to be set accordingly; for if they were set too high, it would completely undermine the success of the school. If the qualifications were low, the scholars would remain in school for a longer time and suffer from the want of a proper classification. The high school room could accommodate only fifty scholars, and that came into play with admissions and qualifications. The committee wanted to make sure that students had general knowledge of spelling, English, grammar, geography and arithmetic. According to the 1852 Woburn School Report, the committee worked diligently to "prepare questions which shall fairly test the scholars' knowledge of these branches."

The 1856 report mentioned that there were three courses of study: a four-year general course, a four-year college course and a three-year course composed of the first three years of the general course. In the same year, the committee decided to enhance the program of study by requiring four years for graduation. The reported also stated,

> *The course was adopted after much deliberation and was believed to embrace all which is necessary to be accomplished by a son who is to be fitted either for a collegiate education or for the walks of business or for a daughter who is to be sent forth to the work, fitted for the discharge of any feminine duty liable to be claimed of her.*

Students in the 1860s took first-year courses in English, reading, bookkeeping, surveying, Latin, French, botany, astronomy, mental philosophy, moral philosophy, trigonometry, grammar and composition. Students ranged in age from seventeen to nineteen when they completed a full course of education. Second-year offerings included English, Latin, physical geography, astronomy, plane geometry, botany, zoology, mineralogy, geology, Greek and physics. Third-year students took English studies, French or advanced astrology and advanced algebra, Greek, chemistry with labs, civil government, German and solid geometry. Fourth-year students took English, Latin, German, trigonometry, surveying, advanced physics and advanced geometry. Greek was designed for those

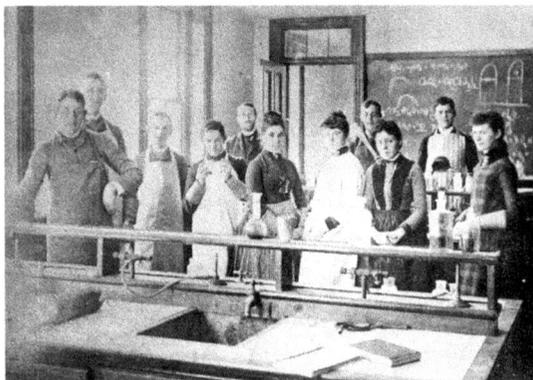

Principal Herbert B. Dow with his class in 1889. From left to right are Charles Wright, unidentified, Leonard Buchanan, unidentified, Principal Dow, Alice (Wyer) Champney, Edith (Brown) Ramsdell, William Crosby, unidentified, Jacob Winn Brown and Florence Munroe. *John D. McElhiney collection.*

pupils preparing for college, and all courses in the college track had to meet the strict requirements of college admission. Music and drawing were required for all years starting in 1865.

According to Leon Basile, class of 1973, in his book *A Union Town during the Civil War*, the 1865 school committee gave a speech directed toward women graduating: "If our young ladies who excel in scholarship have a talent for teaching, or as contributors to periodical literature, let them use it if they are so disposed." In the same report, the committee expressed apprehension at the fact that "intelligent young women with delicate constitutions were advancing to high grades, where excessive study could undermine their health."

Prior to 1870, the school operated on a half-day system, with a morning session from 8:45 a.m. to 11:30 a.m. and the afternoon session from 1:30 p.m. to 4:15 p.m. The system allowed more boys to continue their educations, as they could work after school. This half-day system was unusual for that time.

Due to the new course of study and advanced requirements for admission to colleges, there were many complaints of overworked pupils. There was also concern that students could not complete the full courses of study without injury to their health because of poor ventilation in the building. The 1896 Woburn School Report noted sessions were held from 8:15 a.m. to 1:00 p.m., which was a long time without healthy air to breathe. "This condition compels an early and often hasty breakfast and a cold and indigestible lunch and exhaustion before the time for dinner that unfits the pupil for profitable study." In the Woburn School Report of 1888, military (drill) science was added after students went to the school board asking for instruction in military drill, as many surrounding towns had provisions for such instruction. The committee approved, as it believed that the physical effects of such training were good and that the discipline acquired would be valuable to the pupils later in life.

Activities

The *Luminary* was a small handwritten pamphlet in which the class of 1855 wrote comments and passed on to others to read and write in. According to Bryant Morey French, class of 1933, "The *Luminary* gave an insight into the trends of serious thought of the young people of that generation. The boys and girls had no moving pictures, no radios, and very few weeklies were not of a serious nature. To nourish their minds they depended mostly upon the classics, religious tracts and the Bible."

According to the 1887 school archive book, a battalion was organized through the efforts of a few boys. After a meeting was called and officer elected, a battalion was officially formed in September 1887. By 1888, the battalion had received muskets and gave an exhibition drill after school in the high school hall. Around 1889, the Mass School Regiment (Field Day) was established with rules and regulations created by the principals of high schools in several towns, including Woburn. Medals were awarded for excellence in formation, pace and movements for competitive drill, parade and dress

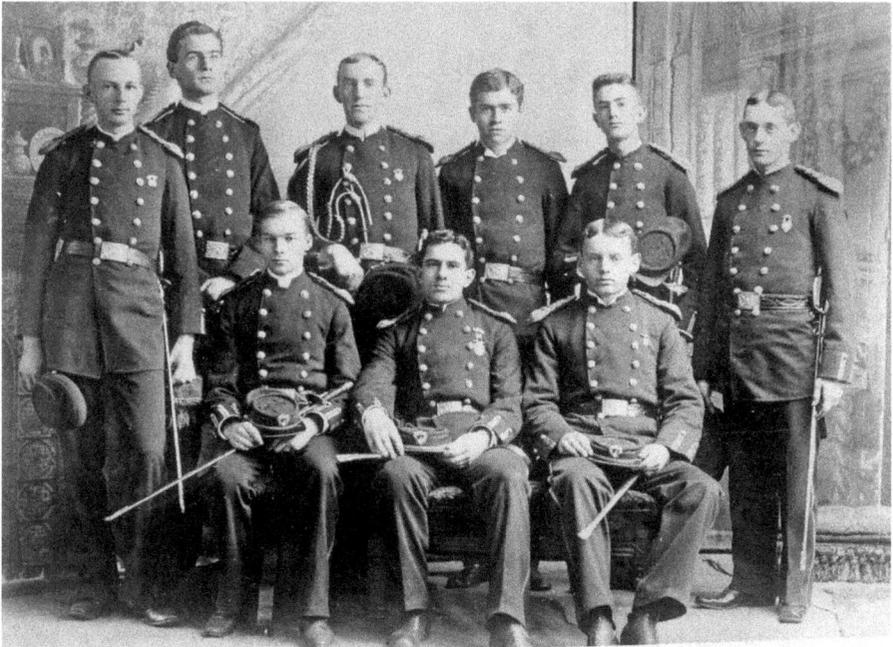

The 1893 Woburn battalion. From left to right are (seated) Carl S. Dow, Charles T. O'Brien and John E. Buck; (standing) (first name unknown) Barrett, Philip Brown, William A. Russell, Jim Byrne, (first name unknown) Danforth and Frank Sawyer. *John D. McElhiney collection.*

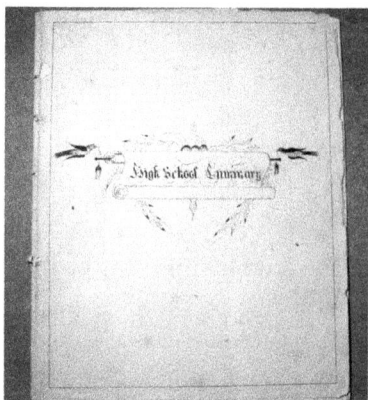

The *Luminary* was a small handwritten booklet passed among the class of 1855 and read by each one. *Woburn Memorial High School archive collection.*

parade. This event was held on the second Saturday in May each year, with Woburn participating at this out-of-town event.

Lyceum Hall was one of the most prominent buildings in town and hosted many school and community events. Built in 1855, this beautiful three-story Italianate hall on Main Street had a dome, an arched ceiling and a large lecture hall with seating for several hundred people. This famous hall hosted graduations, dances, lectures, boxing matches and political events. Two other buildings hosted events as well: the Auditorium on Montvale Avenue (now the Woburn Bowladrome property) and the state armory, built in 1917, which still stands at 35 Montvale Avenue.

ATHLETICS

Athletics were a minor facet of the school culture during this decade. According to Leon Basile's *A Union Town during the Civil War*, a football match between the Warren Academy and Woburn High School, with fourteen students each, was held in a large field near the Mishawum House. Woburn won three of the five games with varying rules; some matches lasted between three and eleven minutes. In 1892, a baseball team was introduced and had a victorious game against Stoneham. Baseball had a strong community interest and soon would become the most popular sport in town.

FUN FACTS

- Teachers organized the Woburn Teachers Association in 1857.
- The principal made thirty dollars a week, first assistant eight dollars a week and second assistant three dollars a week.
- The average yearly expenditure per pupil in 1875 was $13.71.
- Male teachers earned $65.28 per month, and female teachers earned $22.27.

The 1892–93 football team, likely on Abbott Street (later Federal Street) with the Savings Bank block to the left and the town hall in the distance. *John D. McElhiney collection.*

- An apology/contract book was kept from 1898 to 1906. Students wrote apologies and presented them to the principal. For example, "I wish to apologize to Mr. Owen for my ungentlemanly conduct in his office yesterday."
- The Skinner family donated a Caesar Augustus statue in memory of James Lambton Skinner, class of 1890.
- The class of 1889's class gift was a set of attractive bronze electric torches installed on either side of the front door.

TRADITION

The Story behind Graduation

Through the years, graduation exercises have been held on various days, at various times and in various locations. Inside locations have included a grammar school, high school hall, Lyceum Hall and an auditorium, while

outside venues have been the front circle area of the 1906 building, Connolly Stadium and Joyce Middle School. Prior to 1964, students wore graduation attire that consisted of a black cap and gown. In 1965, a color change was made: boys continued to wear black, and girls wore white caps and gowns along with a black and orange tassel. The gowns in the late 1970s had the city crest and later the school crest embossed in orange on the front.

The first graduating class held its commencement examination at the grammar schoolhouse in District One on Friday, July 27, 1855. The graduating class consisted of ten girls and one boy. The students were Amelia J. Andrews, Mary S. Brackett, Elizabeth H. Collamore, Anna E. French, Martha W. Hill, Florence K. Holden, Louisa B. Horton, Harriet Nelson, Martha W. Pearsons, Marietta Thompson and Abel T. Winn. At the close of the examination, Master Stone read the report for the term, and chairman of the school committee the Honorable A.H. Nelson

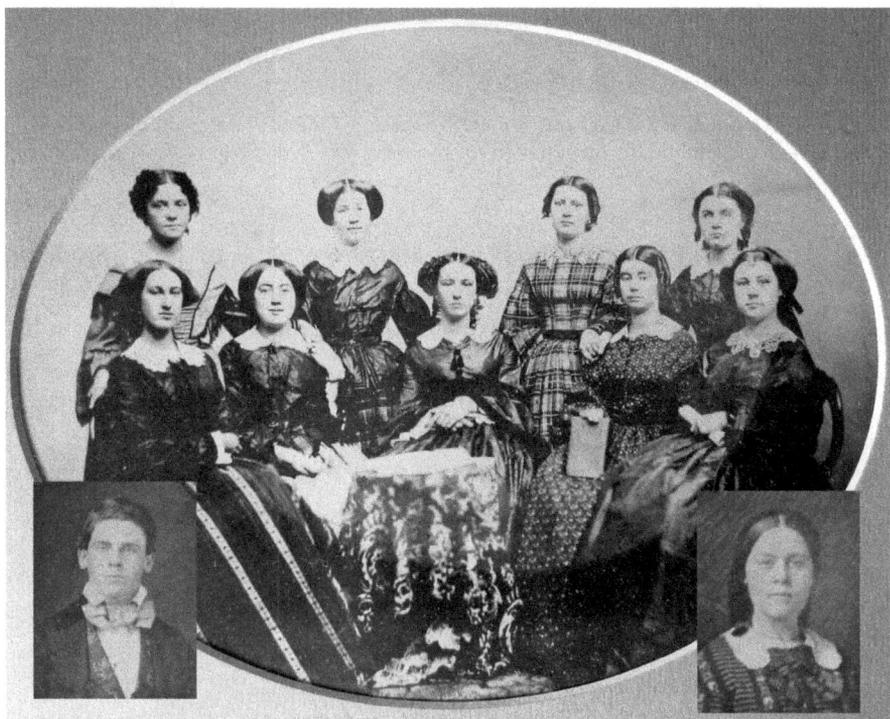

Pictured here in no particular order are members of the first graduating class, the class of 1855: Amelia J. Andrews, Mary S. Brackett, Elizabeth H. Collamore, Anna E. French, Martha W. Hill, Florence K. Holden, Louisa B. Horton, Harriet Nelson, Martha W. Pearsons, Marietta Thompson and Abel T. Winn. *Woburn Memorial High School archive collection.*

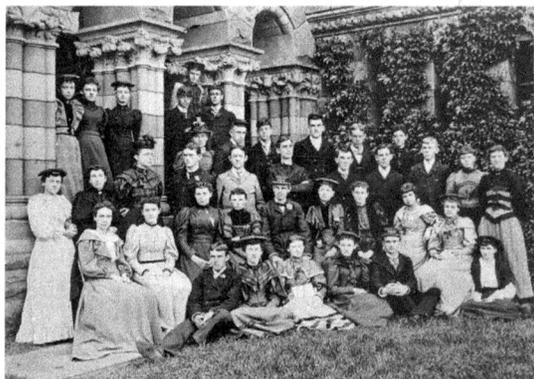

The class of 1894 in front of the Woburn Public Library. *Woburn Memorial High School archive collection.*

addressed the school, as reported by the *Middlesex Journal* on August 4, 1855. Nelson complimented the scholars on their diligence, unwearied application and the high state of proficiency in their studies. As he addressed the class, he also directed his comments specifically toward the ladies: "You have been educated to fill and pursue employments, but above all to beautify and adorn our households." Even though more girls attended and graduated from high school, the young men of this era were the only ones who could pursue higher education. The young ladies were always denied the chance to continue their educations, and it was duly noted. The 1887 school archive book noted that the graduation format changed through the years. The class of 1861 held its examinations at Lyceum Hall in front of a crowded audience, and students recited Greek, Latin and French and read original English compositions and essays. Speeches were read by the school committee, salutatorian, valedictorian and several reverends. At the end of the exercise, the school committee chairman presented the diplomas, and the graduation concluded with a song and a prayer.

Between 1871 and 1873, the name of the exercise changed from Order of Exercises at the Examination to just the Order of Exercises. The format was described in the 1891 graduation exercises, which took place in the Cummings School Hall.

The platform was decorated with ferns and potted plants while the wall behind was covered with a mass of hemlock boughs draped with the class colors of primrose yellow and white. In the midst of this green background two horse shoes were suspended and under them the class motto, Praesis ut Prosis *(lead in order to serve), in yellow and white roses. At 3:00 p.m. the scholars of the high school filed into the hall and took the assigned seats, the*

graduating class upon the platform and the undergraduates on either side. The young ladies of the graduation class were, with one exception, neatly and effectively dressed in gowns of embroidered muslin whose total cost exclusive of mere labor was limited to eight dollars and most of them wore white and yellow roses.

Today, graduation takes place outside on a Sunday afternoon at Connolly Stadium during the first weekend in June. Students and their families celebrate this wonderful milestone with smiles redolent of accomplishment.

6

1900–1909

If You Build It, They Will Attend

On the diffusion of education among the people rests the preservation and
perpetuation of our free institutions.
—Daniel Webster, May 15, 1907

The country made progress in electricity, petroleum and steel production during this decade. Families were close knit, and many gathered together to sing songs and listen to music by paying song pluggers, who carried pianos on their horse-drawn carriages. Ballroom dancing was popular, along with new dances such as the jitterbug, cakewalk and one step. Girls' clothing consisted of dresses with undergarments, and boys wore long trousers and jackets. The country's attitude toward education was beginning to change, and many desired a college education. As the new century began, the population of Woburn was fourteen thousand, and several new institutions were established: the *Woburn Daily Times* (1901), the high school (1906) and Charles Choate Memorial Hospital (1909).

There was very little information archived on this decade, but several important events occurred. The last class to graduate from the Main Street building was memorialized with a beautiful framed portrait. Students witnessed the building of the new high school on Montvale Avenue, which was just a short walk from their building on Main Street. High school was becoming a preparatory school, and evidence existed that a new building would strengthen the curriculum and meet the needs of the community. The dedication of the new building took place in

The class of 1906, the last class to graduate from the Main Street high school building. *Woburn Memorial High School archive collection.*

1907, with the entire community celebrating, including William Stone, the first principal. At ninety years old, he still retained a deep interest in Woburn and loved the school.

FACULTY AND STUDENTS

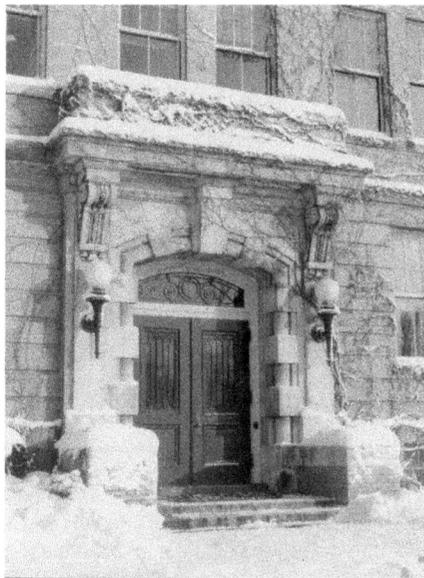

According to the 1912 school archive book, L. Hebert Owen continued as master, believed in a high order of scholarship and was devoted to his position. In 1908, Owen departed, and George Low, who was then submaster, presided over the school. According to the *Woburn Daily Times* anniversary edition, Low was a consummate disciplinarian who demanded that rules be kept all the time. He believed that athletics were extracurricular and not as important as academics.

The majestic front door of the 1906 Woburn High School. *Author's collection.*

ACADEMICS

The business department was extremely popular, and with the growth of the school, typing and stenography classes were overloaded. Students were also enrolled in English, history, algebra, bookkeeping, business forms and practice, chemistry, commercial law, drawing, French, general science, geometry, German, Latin, library science, military drill, music, physical culture, physics and physiology.

In 1907, the Harlow Library Fund, in accordance with the will of Dr. John M. Harlow, was created for the establishment and maintenance of a reference library and the purchase of works of fine art for the public high school. Dr. Harlow was one of the oldest and most prominent physicians in the New England area.

In 1905, student Beatrice Grant won first place in a *Boston Herald* contest for her Lewis and Clark Exposition Display. She earned more votes than any high school contestant in the state. In order to win, pupils were obliged to buy the *Herald*, clip a ballot sheet from the paper and mark their selection. Woburn had the greatest number of ballots and was awarded pieces of statuary. The 1906 annual school report listed the awarded pieces: a seven-foot statue of Minerva (Athena), a three-foot statue of Lorenzo de

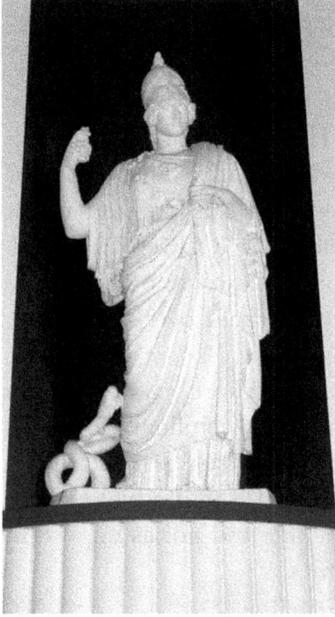

Medici, a relief of Madonna and child by Lucca della Robbia, a small cast of Venus Genetrix, a small cast of Augustus, a bronze bust of Dante, a bust of Hermes at Olympia, a bust of young Octavius and a relief of the Parthenon Horsemen.

Left: One of the many pieces of art relocated from the 1906 building. The statue of Minerva is now located in the auditorium of the new 2006 building. *Author's collection.*

Below: This relief of the Parthenon Horsemen is located in the main foyer area of the new 2006 high school. It was relocated from the 1906 building. *Author's collection.*

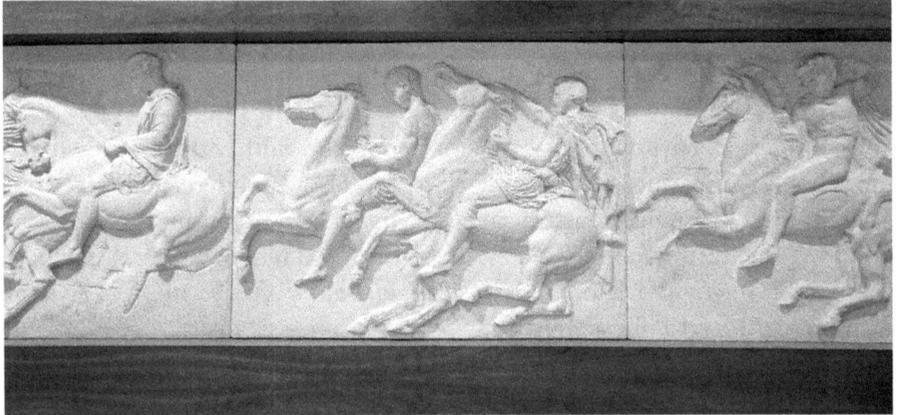

ATHLETICS

Woburn won the 1905 baseball championship of Mystic Valley and was presented with a silver vase emblematic of the Mystic Valley Baseball League. Many fundraisers were held for the baseball team, including a dance in 1906 for which tickets sold for twenty-five cents. The first mention of hockey was in 1902, when Woburn played in the suburban league. Even though football games were played for years, an official

football team was not established until the 1901–02 season, when the team went undefeated under coach Frank Clark.

FUN FACTS

- Teachers' salary was $750 per annum.
- Students participated in the saving stamp program.

TRADITIONS

The Story behind the Tidd Scholarship

In the annual school report, the Marshall Tidd Scholarship was established by Marshall M. Tidd of North Woburn in 1906. A $2,000 trust fund was created for two scholarships to be given out each year, one to a male and one to a female. The principal of the school, the mayor of Woburn and the president of the Women's Club were to make the selections. Tidd asserted, "The beneficiaries of these funds need not be of the highest scholarships, but they must be of the highest manly and womanly characteristics." Marshall Tidd was a well-known civil engineer and one of the oldest members of the American Society of Civil Engineers.

1910–1919

The Struggle to Attain an Education

Woburn High School today means more to this community than ever before.
—Principal George W. Low, 1913

The United States' involvement in World War I had tremendous effects on the country, as boys were drafted right out of high school and women filled their places in factories. Ruth Stretton Boyden, class of 1917, remembered that World War I claimed young men from her graduating class, and many civilians died from the great influenza epidemic. Ruth was very patriotic and volunteered for the motor corps; she was assigned to drive a local doctor to his house calls. The United States was considered a world leader for the first time, and the government instituted new patriotic and national programs in schools. Families during this decade were close knit, and clothing styles reflected the effects of the war. Clothes became very practical, with dresses cut shorter due to material rationing and boys wearing military details on their clothes. Ruth also mentioned school attire: "Students never came dressed as one would go to the beach. You didn't have peekaboo blouses. That would not be acceptable."

A new movement began to appear and spread around the country, and it was called "high school." According to the 1912 school archive book, the youth of America enrolled in secondary schools at a rapid rate, creating the need to build and revise curriculums that would prepare students for life rather than college. Two-thirds of the children in Massachusetts left school before the age of sixteen in order to go to work.

The post office on Federal Street opened in 1911, and motorized engines came to the Woburn Fire Department in 1913. The telephone became a popular item in the home, and presentations were made by the telephone and telegraph company to students on the importance of the technology. Slides were used to show a model switchboard and how to handle calls. A note in the 1918 school archive book mentioned schools were closed due to Spanish influenza. Pupils were ordered to stay home and indoors when the weather was damp and clammy. Physicians and health board directors pointed out that a return to sunshine and dry weather would quell the spread of the epidemic.

FACULTY AND STUDENTS

Principal Low's salary was $2,100 a year when he resigned following the 1916 school year to be principal at Swampscott High. In 1916, Orel M. Bean, a Bates College graduate, became principal with the starting salary of $1,900. Bean was extremely familiar with the school, as he previously was a submaster and teacher. He was dedicated to his students and maintained a "stern demeanor." A biography printed in the 2002 *Woburn Daily Times* described him as "quiet in nature, but forceful in the center office."

A typical school year began on the first Monday of September and continued for forty weeks, running on a six-period schedule with twenty minutes for lunch (recess) during period four. The length of the school day was from 8:30 a.m. to 1:15 p.m. Ruth Stretton Boyden recalled in the *Daily Times* how strict it was at school and that there was lots of homework. "There was a lot of grammar being taught, diagramming of sentences and reading. The school day would start off with a salute to the flag, followed by a reading from the Bible by the teacher then a reciting of the Lord's Prayer." The 1912 rules and regulations of the school department listed that morning services in each room had to begin with the reading of the sacred scriptures by the teacher, followed by the repeating of the Lord's Prayer.

There were ten women teachers in 1910 and sixteen by 1919, with teaching salary ranges listed from $400 to $750. The 1912 rules and regulations also stated, "Whenever a women teacher or principal in high school is elected, her position in the schedule shall be determined by vote of the school committee and may be either higher or lower than the position in the schedule to which she would be entitled had all her service in teaching been in Woburn." The report also listed disciplinary rules: "Teachers shall

aim to practice discipline as would be exercised by a kind and judicious parent, avoiding indiscrete haste and resorting to corporal punishment only in extreme cases. Corporal punishment shall not be inflicted in school hours, nor before other pupils, and a witnessing teacher shall be present when punishment is inflicted."

One of the responsibilities of the principal was taking care of the flag that was flown at the school. The national or state flag was extremely valued, and strict guidelines had to be followed on how and when to fly the flag. If a storm arose during the day, the flag had to be lowered at once; if the flag was torn or injured, it must be reported to the superintendent.

Everett Ward, class of 1912, recalled his high school days in a letter to the school: "I covered the most amazing details of the four years spent in Woburn High. Got the confused sensation of the first freshman days, indulged the 'oh I am so superior' sensation of being a senior, galloped madly around the corridors between periods, suffered the agony of the last five minutes of a period, circled the corridor twice to pass a note, loved this teacher desperately, hated that one persistently and right or wrong stuck up for Woburn High." Ruth E. Clement Hilbrunner, class of 1919, recalled how she enjoyed "Miss Morton's drawing classes and took great pride when Miss Morton showed the class how to make stained glass windows." Ruth was so enthusiastic about the project that she ended up making a design she later sold.

ACADEMICS

The 1912 school archive book reported that the graduation rate was 46 percent, and many families struggled to keep their children in school. The mayor and the principal realized this and put forth new ideas to enhance students' learning experience even during these difficult times. The book also mentioned that

> the course of study was totally revised into four groups college prep, general, Latin scientific, and business in an attempt to meet modern demands. The curriculum included English, algebra, geometry and solid geometry, science, physics and chemistry. Foreign languages offered were German, French and Latin while Greek was eliminated. Music and art courses were once a week and business courses of business practice, stenography, typewriting and bookkeeping became a priority.

Many local companies had a huge demand for graduates who had business skills. In 1912, Margaret Martin wrote the newspaper: "After I graduated from WHS, I obtained a permanent position as a stenographer. I honestly believe that after having taken the business course the graduates do not require business college training." Most students graduated from the general preparatory course, then the business course and finally college preparatory. The first mention of grading was reported as follows: A meant honor, B meant good, C meant passing, D meant failure, E meant bad failure and F meant utter failure. Notices were sent home through the mail to parents of pupils who had unsatisfactory records in scholarship or conduct. Bimonthly report cards had to be signed by parents and returned at once. By 1914, a new system of promotion had been established at the school; scholars were classified under the headings "promoted with honor," "promoted with credit" and "promotion." In order to secure the school certification for admission to college, pupils had to have an average of at least a B. According to the New England College Entrance Certificate Board, Woburn High School made the list of approved schools. This meant students with good records did not have to take college entrance exams.

Military drill was added to the curriculum in 1912, a required subject for all boys that merited wearing uniforms to school. Morning exercises were conducted daily from 8:10 a.m. to 8:51 a.m. at the Woburn Armory. One disciplinary action was noted when boys failed to wear their uniforms to school on drill day. This slight display of rebelliousness in the battalion caused Principal Low to speak to the students for their "saucy replies" as to why they would not wear uniforms to school. Four students were sent home with discipline action notes. This display contrasts with what Thomas J. Glennon, class of 1918, wrote in his published recollections of the enjoyment of wearing his uniform to school. "What a joy it was on each Tuesday to dress in white trousers, legins, blue jacket and peaked hat for the one period of military drill!" Since boys were required to take military drill, the girls were required to take a physical culture education course. In 1916, the girls from the senior class petitioned the school committee to replace their physical training class with military drill. The signed petition was denied, but soon after the girls began to refer to their class as their "Physical Torture" class.

Principal Low established a consulting body of pupils, which consisted of two representatives chosen from each of the eleven homerooms. "This body will serve as a channel through which ideas and opinions of the student body may regularly be presented to the principal." The organization helped make Low aware of and understand the concerns and issues of the students.

ACTIVITIES

One of the first descriptions of a dancing party came from the 1912 school archive book. It noted, "Members of the senior class formed a committee and sent out formal invitations. The dance was held in the high school hall and ran from 8:00 p.m. to midnight with a cover cost of fifty cents. The Crestant Orchestra furnished the music for dancing in an efficient manner and a pleasant evening was had by all." Dancing to certain types of music was a controversial topic, and under the title of "Frowned upon Modern Dances," the class of 1914 discussed whether or not the newfangled objectionable dances would be allowed. In a unanimous decision, they decided that these dances should not be permitted. Tango dancing and so-called society dances were tabooed by Principal Low. Girls filled out small booklet dance cards that listed the order and type of dances beside a space to write down a partner's name. The dance card cover was decorative, with the date, time and a color tassel on the side.

According to the 1912 school archive book, three major events were established in this decade: Field Day, the military ball and the senior class activities. Students had competed in Field Day events in other towns as part of the Second Mass School Regiment. The first Woburn Field Day was held at Library Park on June 4, 1913. The event consisted of exhibition drills, field sports and the awarding of prizes for best setup and most soldierly companies. Hundreds gathered to watch these drill exercises along with field events such as the shot put and high jump. The military ball was started in

A dance card from 1913. *Woburn Memorial High School archive collection.*

The 1912–13 Field Day battalion. *Woburn Memorial High School archive collection.*

1912 and considered one of the most popular events of this decade. Usually, 100 couples were present at this event, and young gentlemen proudly wore their military uniforms while escorting their dates. The event was held at the Woburn Armory, and tickets cost fifty cents. By 1916, the ball had become extremely popular, and 250 couples attended, with 100 couples participating in the grand march. The event was from 8:00 p.m. to midnight, and Feeney's Orchestra played an array of music, with the waltz and fox-trot being the most popular. In the early 1910s, senior class activities included a reception, dance and graduation. The class of 1913 held its reception at Lyceum Hall, where 500 guests were in attendance and enjoyed the order of exercises, which included planting of the ivy, class history, vocal solo, class statistics, a class prophecy, class poem, xylophone solo, the presentation of class gift and singing the class song. At the 1917 reception, the class president gave out badges that recipients were required to wear all evening. Badges were awarded to both girls and boys in the following categories: the girls were awarded badges for class flirt, class sport, most bashful girl, wittiest girl, best dancer, best-natured girl, class bluffer and most popular girl. The boys were

awarded badges for class flirt, best dancer, sleepiest boy, class sport, class bluffer, wittiest boy, most bashful boy, class dude, best-natured boy and most popular boy. Seniors selected their class colors and class mottos two weeks before school closed. The colors were displayed on invites, dance cards and diploma ribbons. During this week, the senior dance and graduation were also held.

ATHLETICS

A letter from Principal Bean was sent to the citizens of Woburn in 1913 soliciting athletic support. The letter called "attention to the fact that athletics have a recognized place in every modern and well regulated institution of learning and they should receive due interest and support." An all-season pass for one dollar was offered in order to support school athletics. Ruth Stretton Boyden recalled in an article by Marie Coady,

There were no organized athletics for women students. About all we did was to get a blouse and buy some bloomers and have physical education. It was the baseball that was really big. Not much was heard about football, Woburn was baseball. The intense rivalry was with Stoneham. It was service business in those days. The entire student body would go to Library Park and to Stoneham for the games.

The sports story of the decade was a controversial baseball game played against Stoneham High School in 1914. The 1914 school archive book noted, "Everyone in the school rallied around the baseball team as girls wore armlets of school colors and waved flags and pennants. There was a mass meeting at the high school to rehearse songs and cheers that would feature the battle of Stoneham versus Woburn. It is the most enthusiastic demonstration in the history of the high school." The local paper reported, "A person who is incapable of showing true school spirit is not the kind of a boy who should be permitted to associate with the ordinary American youth." It was estimated that four thousand fans participated in the greatest demonstration in the school's history, when Woburn beat Stoneham to win the Middlesex Cup. There were parades, speeches, cheers and songs as crowds marched to the homes of Principal Low and Assistant Principal Orel Bean. Fireworks were seen in the sky, and the crowd paraded through the center of Woburn. The celebration would soon be tarnished, as days later

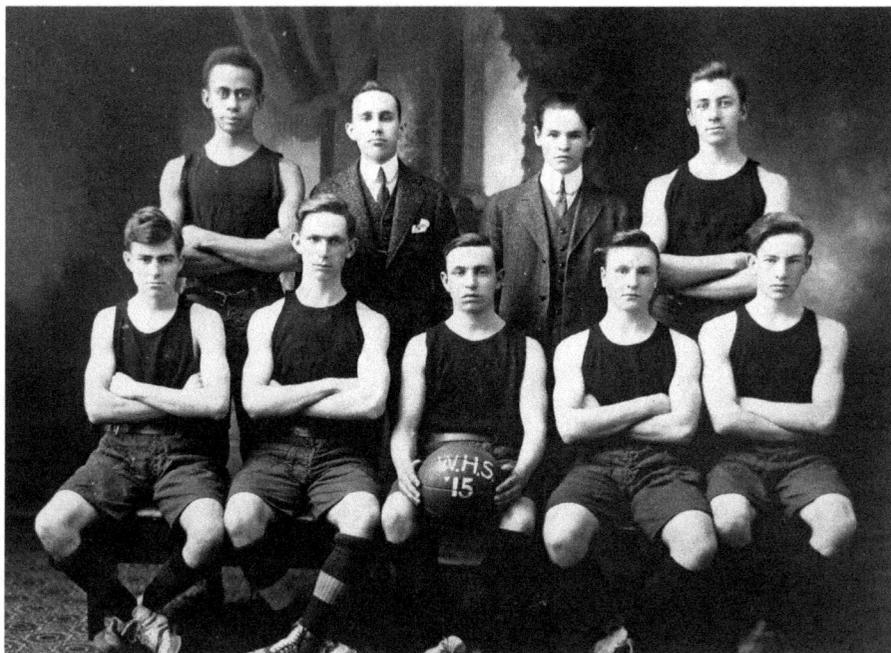

The first basketball squad, 1914–15. Pictured here in no particular order are William Mulcahy, Charles Loring, Arthur Finnegan, Arthur Conlon, Birdie Latham, Constantine O'Doherty, Gerald Moreland, E. Curtain and C. Curtain. *Woburn Memorial High School archive collection.*

protests began due to the length of the pitcher's box. Woburn kept the cup, but this issue eventually went to court for a ruling. Some wanted the game played over, but Principal Low stood his ground and believed that Woburn had won the cup fairly. This controversy barred Woburn from the Middlesex and Mystic Valley Leagues for five years.

The first basketball squad was organized by coach John McGlew during the 1914–15 season. Carl Provost noted, "Woburn lads had never seen the game played to any extent. There was no gym to practice in but Mr. McGlew did arrange with the Woburn Armory to use their facility for games and practices. Their season record was four and ten." Hockey was mentioned in 1911 and then again in 1917; Woburn played in an intramural league until 1926.

A standout athlete, James Joseph Connolly, class of 1918, was considered a hero in the city of Woburn. As mentioned in the book *Woburn Forgotten Tales and Untold Stories* by John D. McElhiney, Connolly was a member of the student body who played baseball and football on the school team. He loved to run races even though there was not a track, cross-country team or coach

at the school. In 1918, he won the New England Mile Championship, which gave him recognition in the state and a cause for celebration in Woburn. Over 3,500 people attended Jimmy Connolly Day at Library Park for a track and field event. After graduation, he attended Georgetown University and participated in the 1920 and 1924 Olympics. He achieved local, regional and national status as a mile runner and at one time was one of the premier runners in the country. In 1954, a dedication ceremony was held in Jimmy's honor and the football stadium renamed Connolly Stadium.

FUN FACTS

- In 1910, the cost of coal to heat the school was $5,083.
- Principal Low suggested taking a class photo as a cost-effective measure, instead of purchasing individual portraits for everyone.
- History classes debated this question: "Are moving pictures beneficial?"
- Dance chaperones were called matrons.
- A Victor Talking Machine was purchased in 1912.
- Expenses for events were recorded for a 1914 dance: sale of tickets, seven dollars; police, two dollars; cornmeal for floor, thirty cents; janitor, five dollars; printing tickets, seven dollars; automobile for matrons, five dollars; telephone, ten cents; music, eighteen dollars; palms/favors four dollars.
- The first annual public speaking contest was held in 1914.
- Any boy chewing tobacco would not be allowed to represent the school in any branch of athletics or the battalion.
- Boys were given a free booklet on the use of and abuse of firearms.
- On May 17, 1916, high school students were so drenched from the rain that when they arrived for school Principal Low decided to call off the school session.
- The opening of the 1916 school year was postponed due to precautions taken against infantile paralysis.
- Thrift stamps and Christmas Seals were popular.
- Peach stones and nut shells were collected for making charcoal for gas masks.
- Gardens were constructed in the rear of school in 1918 to meet public need. Boys were excused from school in June to harvest the crops.

- The senior class play was a highlight for the seniors and held each spring at Lyceum Hall.
- In remembrance of President Lincoln, Lincoln Day assemblies were conducted in Assembly Hall. The public and guests of honor listened to patriotic songs, an orchestra, a proclamation by the governor and the Gettysburg Address.

TRADITIONS

The Story behind Parents' Night

In the 1910 school archive book, Mayor Henchey stated, "We need to throw open the building for inspection to give all parents an opportunity to meet the teachers and to foster a spirit of cooperation without which schoolwork cannot be most successful." Henchey's suggestion led to Parents' Night being established on October 17, 1913. There was a tremendous interest among parents, as this was the first time many of the them had ever been inside the school. Principal Low remarked, "The school has grown very rapidly in recent years. The building was occupied in 1907 and the total membership was just 255. Today we have had growths of 80 percent in just seven years with a total membership of four hundred fifty."

1920–1929

Growth, Transition, Opportunity

One of the many important things you should always remember is that you are in school for an education. You are here for yourself for your own development and you should improve every opportunity to the end that may develop to the highest degree possible. Every minute, hour and day counts, every subject counts. When you neglect a given study, you neglect yourself. Today is yours, make the most of it, you cannot count on another day.
—Principal Orel M. Bean

The 1920s were an age of extraordinary change, a transformation that came in with a roar as the country saw tremendous growth, families moved from their farms to the city and the number of wealthy families doubled. One of the most important innovations of this century was the automobile, which became an alternative mode of transportation. Homemakers welcomed ready-made clothes and new appliances such as the washing machine and vacuum. They also earned the right to vote and began to champion women's causes. The radio was a source of communication for everyone, as stated in the 1925 *Reflector*: "Radios have advanced greatly. Five years ago there were only few crystal sets and only inventors and rich people had tube sets, today every third or fourth home owns a set. One tube lets a person hear about two thousand miles. Lately radios have been progressing with ten to twelve tubes. A scientist stated that radios will eventually run the world." The choice of dance music was mentioned in the 1926 *Reflector*: "The waltzes are usually good

and almost everybody enjoys a pretty waltz but jazz music has a rhythm of its own and makes a person dance."

Two tornadoes whipped through the city in 1921 and 1925, causing damage to several buildings. The Woburn Country Club opened in 1923, and the city became one of the first in Massachusetts to have freshwater ground wells in operation by 1926. The population of Woburn rounded out to 16,574.

FACULTY AND STUDENTS

Orel Bean continued to teach classes and serve as the principal of the school throughout this decade. There was a tremendous growth in the student population, and by 1925 the capacity was over the 225 maximum limit. The school went to a two-platoon system with morning and afternoon sessions. Bean initiated a homeroom program in which students elected officers and each room had a motto. These rooms became a home base for students as they learned to work together and accomplish tasks such as organizing social gatherings, as described by students in the 1926 *Reflector*: "Room 19 decided to have a Halloween party, the hall was very charmingly decorated and dancing was enjoyed until eleven in the evening, apples and cider were served during intermission." Homerooms became a family unit for the students, and many had fundraisers, songs, poems and stories. Bean loved to place words of wisdom on a pink bulletin, which was read before recess. His noteworthy words inspired the students: "Much that is part of your education lies outside of your books. One of the big things is the acquirement of a cooperative spirit for you must live and work with others and your success will depend in a large measure on your ability to cooperate with others here is the place and now is the time to practice to do your part all along the line."

Teachers were well respected, and that regard was reflected in a graduation speech by Ruth Wheaton, salutatorian of the class of 1924: "To our teachers who have so earnestly and efficiently taught us both in grammar and high school we owe a debt which can be paid only as we put into practice the principles which you have taught us."

The *Reflector* school magazine was established in 1921 and published until 1949. It fostered school spirit, formed a permanent record of school activities and, most of all, gave a voice to the students. The magazine sold for fifteen cents and contained editorials, stories, class notes, illustrations,

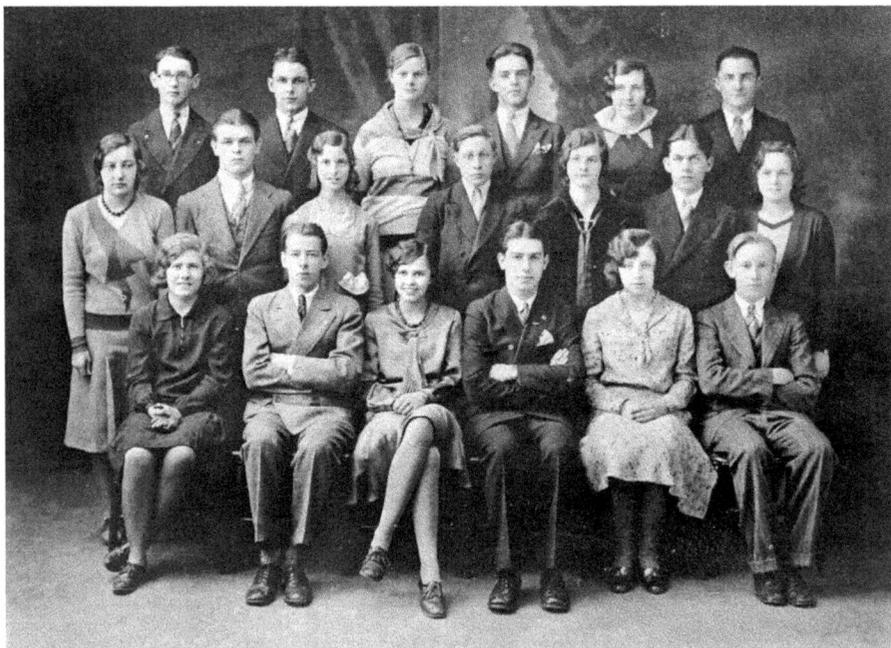

The *Reflector* staff of 1929–30. From left to right are (first row) Margaret Burke, William R. McDevitt, Pauline Wood, Sidney J. Paine, Florence Carroll and Earl Dobbins; (second row) Margaret Brehaut, Frederick Kelleher, Josephine Edmunds, Norman Benson, Elizabeth Buchanan, Arnold Towse and Jean Walker; (third row) John Caldwell, Charles V. Estes, Miriam Johnson, Frank French, Madeline Haggerty and Charles Quinn. *Woburn Memorial High School archive collection.*

poems, alumni jokes, athletics and updates. It was published five times a year by the students. The *Reflector* continued to have a place in the school as the name of the daily bulletin and was distributed to each homeroom from the 1950s until the 1990s.

The *Reflector* printed many student opinons. Mary Salmon, class of 1930, wrote, "We want bigger and better parties. Social gatherings give us a better understanding and appreciation of our teachers and classmates. After our studies in school we need recreation and the companionship of our friends. The senior dance took place the night after Thanksgiving and was a great success, the pop concert given by Miss Feeney our physical training instructor was both original and snappy." Margaret Burke, class of 1930, contributed, "Why go to college? The first and more important as to why go to college is that you get a better education. When you graduate from high school, you have not finished your education. In these days of competition it is necessary to be efficient in whatever you attempt. College is not a place

for slackers, but a magic field of opportunity for ambitious boys and girls." Frances Pollack, class of 1929, wrote, "Loyalty of WHS means not talking in corridors, not passing notes behind the teacher's back doing home work. Picking up paper in the corridors, paying athletic dues taking part in what is going on in school. Obeying the rules of the school, respecting the teachers." Evangelyn Hewes, class of 1925, recalled, "I sit in a seat at a desk in room eight, I'm a senior in Woburn High and although I'll admit, I think it's great. I feel as though I should cry. I hate to think of that day when I must leave this school and say good bye. For four short years I've been in this school and I like my teachers and chums but I hate to think of that dreaded day when I must go from most of these friends and try to make new ones."

ACADEMICS

The curriculum continued to require all boys to have military drill in order for them to know what was required of a soldier, how to obey orders and most of all, how to use a gun. The boys needed be ready to defend their country during a war. Courses in U.S. history and government were revised to meet the new standards, while drawing classes were handicapped by the high cost of materials due to the war. Penmanship continued to be an important course that encouraged pupils to master movement and discipline.

ACTIVITIES

The prize speaking contest was promoted in the 1925 *Reflector* as "one of the best opportunities of self development, to stand on your two feet, face an audience, and be able to say what you have to say without feeling your knees shake and your heart thump double time is a great achievement." Two new clubs associated with Young Men's Christian Association (YMCA) were formed: the girls' club was called Tri-Hi and boys' the Hi-Y. These clubs helped create and maintain high standards of Christian character throughout the school and community.

The class of 1924 set an example for future years with the establishment of the traffic squad. The *Reflector* noted, "When seven seniors received pink slips summoning them to the office, they began to shake in their shoes. But

when they went to the office of Principal Bean, they found there was no cause for fear but had been summoned as a senior council to consider the question of filing between periods." Bean suggested a traffic squad so there would be order in filing. Students would walk on the right and go to the end of the hall and walk back up the hallway into their classroom if it was on the opposite side. One could not cross in front of people to get to the room on the other side. Students would have to talk quietly and file in an orderly fashion. Student Ralph Ayer recalled,

> *Previous to it being formed, the teachers used to stand in the corridors while the students filed. It was necessary for the teachers to leave their work and most inconvenient for them to do this. The traffic squad members near the close of each period would leave their classes to take their respective positions in the corridors and the head of the stairways. Pupils know that they should not talk nor behave in any manner contrary to the rules of the school while passing from room to room. Those who broke the rules were reported to the office and were deservingly punished. Several times during the year the squad meets to discuss problems, each member of the squad wears on his arm an orange band with the black letters T.S.*

ATHLETICS

According to the 1920 school archive book, by the mid-1920s, athletics were becoming a very important branch of the curriculum in both schools and colleges. It was emphasized that the "present day student who does not indulge in some branch of athletics is considered a very good specimen for an instructor of a young ladies knitting and crocheting institution. A student is of a greater welcome to college if it is known that he is an athlete and not a book worm." It was important that the development of school teams and general participation of all pupils in sports were suited to their aptitudes and interests. The ultimate goal was to have physical education, sports and school participation across the board. The only hindrance was the lack of proper playing fields and a track for their teams since athletes could only play at Library Field. In order to organize the athletic teams, the school board hired an athletic director in 1922.

Track, football, basketball, field hockey and baseball were becoming accomplished sports at the school. The 1921 football team won the Mystic

Valley Championship, but it was the three consecutive pennant wins by the baseball team that received all the glory. The 1927, 1928 and 1929 baseball teams coached by Charles Roche, class of 1917, won the Mystic Valley League Championships, with the 1927 team having an outstanding record of 14-3. A victory ball was held for the team at Woburn Armory to celebrate all the wins. Girls competed in field hockey for the Greater Boston League, but the girls' basketball team competed only with several organized teams within the school. The tennis team was fortunate enough to play at the Woburn Tennis Club. Principal Bean presented felt W letter awards and certificates to the boys in Assembly Hall at the end of each season. These certificates were diplomas certifying that the student was entitled to wear the letter, which became a badge of glory for any boy who made a school team.

More students were participating on teams, but there was a concern over the lack of school spirit. It was noted in 1925 *Reflector* articles. Dorothy Johnson

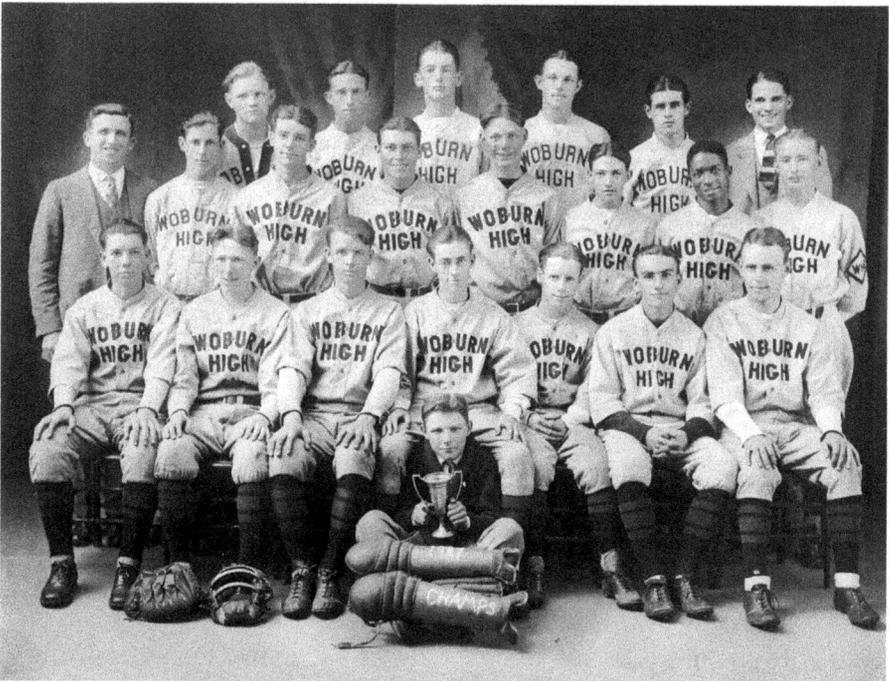

The 1927 Mystic Valley League champions. From left to right are (seated) Harold Hogan; (first row) Ronald Weafer, Charles Donahue, John Costello, Eddie Carey, Bobby Burns, Bernard Keating and Donald Peterson; (second row) coach Charles Roche, Joseph Degnan, Marty McDonough, George Daley, Lefty Flaherty, Dom Shea, Ray Fields and Leo Curran; (third row) Ralph Parsons, Packy Joyce, Tom Hardy, Billy Dunnigan, Ned Murray and Edward Flaherty. *Courtesy of Karen Doherty Gibson.*

wrote, "Come on pupils, show some spirit, other schools have regular school spirit. All of them have a cheering section to urge on the boys or girls who are fighting for supremacy on the athletic field. Wake up, pay your dues, and organize a cheering section." Sidney J. Paine, class of 1930, remembered, "Before the Thanksgiving day game between Woburn and Winchester, anyone walking down Main Street would have noticed something impressive at Van Tassel and Quigley's shoe store as there appeared the orange and black colors of Woburn and the red and black of Winchester. The window display was not so much advertising purposes as it was to show that at least this establishment took some interest in our football squad and high school." Dorothy Mock noted, "Woburn High needs a cheering squad. Why has Woburn football had a losing season for two years? The team cannot work alone, there must be some cooperation with the other members of the school. How can they cooperate? They can form a snappy cheering squad." Thomas Hardy discussed excitement over new playing fields: "The athletic field will be located behind our school extending from Salem Street to Bow Street. There are several acres of swampy and marshy land to be covered with gravel and grass for baseball, football and track teams. A stadium is going to be built around the field so that everyone will have to pay to see a game of any sort. No more will out of town players dread playing on a swampy field."

FUN FACTS

- A short sleigh ride was sponsored by the athletic association. No colds nor sickness resulted from the sleigh ride, chiefly because each rider took turns in running behind the sleigh.
- An Amrad unit wireless receiving station radio was installed in the school.
- The average yearly expenditure per pupil in 1925 was $67.16.
- The class of 1922 was the first to have a class photo.
- Nicknames such as Count, Giggles, Heartbreaker, Bricks, Slush, Caruso and Chicken were given to students.
- In 1926, the maximum annual teaching salary for women was $1,800 versus $2,000 for the men.

TRADITIONS

The Story behind the Thanksgiving Day Game

Woburn and Winchester have been football rivals since 1891, but it was not until 1928 that it became a traditional Thanksgiving Day game. Woburn won the first game and captured the state title that year. Over the years, this Turkey Day game has drawn thousands of fans wearing the Tanner black and orange or the Sachem red and black. The 1970s games drew the largest crowds, with the 1979 game breaking a record with twenty thousand fans watching a thrilling game in which the outcome determined whether Woburn or Winchester would go to the Superbowl. Woburn beat Winchester 22–15 and went on to win the Superbowl. The annual rivalry game continues today as one of the oldest in Massachusetts.

1930–1939

Economic Effect of the Great Depression

I would walk a million miles for good ol' Woburn High.
—*Mary McDonough, class of 1934*

The Great Depression started with the stock market crash in 1929 and carried over into this decade as the country was challenged with this economic crisis. During this time, young boys struggled to find work, and sometimes young women needed to contribute to the family income, although many girls were expected to work toward the ultimate goal of marriage. Parents were involved in many aspects of their children's lives and usually directed their career choices. Catherine "Tina" Tropea Lancelotta would have graduated in 1930, but she left in her sophomore year to help support her parents and eight siblings. Tina said, "It was tough. I had to get a job and I made twelve dollars a week working forty hours in a chocolate factory." Eighty years later, in 2014, Tina received her high school diploma at the age of 101 in a unique ceremony at the high school. Andrew Crawford, class of 1937, remembered, "I was only sixteen when I graduated and I used to come home after school and work the farm for long hours for little pay." Anna Smith Eckberg, class of 1939, recalled, "Some boys joined the military before they graduated. Women went to work in the Watertown Arsenal, and girls learned how to weld. I worked six days a week at my father's meat and grocery store. I remember that people always helped their neighbor." The value of an education became extremely important, as more and more young people began to attend high school, especially males, because there were not

as many employment opportunities for young men. Michael McGann, president of the class of 1939, recounted, "Most people did not go to college. We were lucky to get out of high school. Only the privileged could go to college. The children of dentists and doctors went to college. We all enjoyed school, everyone was friendly, you knew almost everyone and all the teachers. School was our second home."

The *Reflector* continued to be a voice for students. Stephen Griffin, class of 1934, wrote, "This generation of ours should go down in history as one of the most notable of all time. It has endured the worst depression the world has ever known. Because of this depression great social changes are in the making. The economic condition of this country brought to light working and living conditions that you would not believe possible in a civilized country. There were several other great events which our generation has witnessed. The economic conference in London, the Japanese aggression in Manchuria, Hilter's rise in Germany, revolution in Cuba and Chicago World's Fair." The age of progress was noted by Mariam Billauer, class of 1931: "The rushing present age are those indispensables—the telephone and the automobile. In the space of but a moment, one end of the world is connected with the other. Some of the most important modern inventions were the radio and the motion picture. Families also had labor saving items such as the washing machine, vacuum cleaner, iceless refrigerator electric dish washer and fireless cooker." Marie Carroll, class of 1936, noted, "This is an amazing period in American history. There never has been a period in American history so interesting and so stimulating. Not since the Civil War days has any president met with such a hazardous situation."

Girls wore long dresses that fell just above their knee socks, plaid skirts, white pique blouses, summer shorts and weekend rompers. The invention of the zipper gave another option to buttoned clothing. Boys wore long or short trouser pants, tapered and looped for a belt and suspenders. Geraldine Spencer, class of 1933, noted, "The upright dashing young men in flannels and ark jackets are hardly the same when they came here four years ago in short trousers and high pitched voices. The charming young ladies no longer have shiny noses, pale lips or short skirts."

The city of Woburn decided to do something out of the ordinary and borrow $1 million to build a new city hall even though the country was in the midst of a depression. At the same time, the city was putting the finishing touches on the new junior high wings for the 1906 building. It also experienced two major disasters, with the Strand Theatre catching fire and

the Great Hurricane of 1938. Michael McGann, president of the class of 1939, spoke about the hurricane: "We were playing football and the wind and rain came fast. I punted the ball and the football carried all the way to the cemetery. We went to the locker room and had to stay there for awhile. All the trees on Main Street came down. There were no power saws so we had to use hand saws to move the trees."

FACULTY AND STUDENTS

Principal Bean began this decade with former teacher Shipley Ricker as his assistant principal. Bean stressed the importance of the homeroom period for the purpose of character building and training, as some of the activities were devoted to school pride, traffic conditions in the halls, the number of hours of sleep needed and character development. Dorothy Andrews, class of 1934, mentioned the phrase "learn to do by doing," a familiar saying that every pupil knows. It has been placed on the blackboard in many rooms as a slogan by which the room progresses. Students loved being in their homerooms because they felt at "home," and each room took on a personality of its own. There were miniature elections, contests and superlatives. Some notable superlatives in one room were most popular boy, Lefty Cogan; class artist, Tom Pecora; popular girl, Tex Murphy; Irish dancer, Dick Connolly; and happiest girl, Mary Salmon. The homerooms also wondered what would happen if Eleanor Daw stopped smiling, they only had three weeks of summer vacation, all the boys left school or Margaret Bushman lost her curls.

Earle Cheney, class of 1934, described his first day of school experience: "Through the doors we curiously peered, wondering what fate held in store for us. First, we had to find our homerooms, and as you might suspect, many errors were made to much amusement of the wise and naughty upper classmen. Yes, we believed everything they told us: but we soon learned to be just a bit wary of their advice all too anxiously given." Geraldine Spencer noted, "We entered Woburn High one lovely September afternoon in 1929. We then met many new faces and made firm friendships that have meant so much to us in four years passed."

ACADEMICS

Woburn High, through the labors of its principal and faculty, was well respected in the standards that colleges had come to assume. Student E.B. Blake noted,

> *The teachers have always been efficient, capable and interested in their students. The courses of study have always been excellent in every way. Alumni have always been grateful for the splendid preparation which they have received. Those of us who have spent four profitable years at Woburn High appreciate what a splendid institution it is. We appreciate the opportunity which is at present yours, as it was ours, in Woburn High School.*

Students continued to tackle homework and respected the school campus. George Bravacos, class of 1935, noted, "It is not unusual to see a group of students sitting in the homeroom before school, discussing the all important topic of the day—last night's homework." When the new wings were added, new courses such as practical arts, household management and home economics enhanced the curriculum. Several courses were set up by sex; the girls had to take cooking, and boys took carpentry and printing. Rosalie Tirrell, class of 1935, stressed the importance of an education and a diploma:

> *The high school diploma certifies that they have passed successfully the requirement necessary to obtain it. But to many outsiders who have received one it means a great deal more. It signifies that the owner, while obtaining a knowledge of the fundamentals of certain subjects, has, at the same time, developed his character, good manners and a love for the better things of the world.*

ACTIVITIES

The high school had become the center of social activities for the whole city, as the school continued to showcase events during the year, including the Lincoln Day assembly, glee club, band, public speaking contest and senior class play. The music program was a popular activity, as Jeannette Zimbel

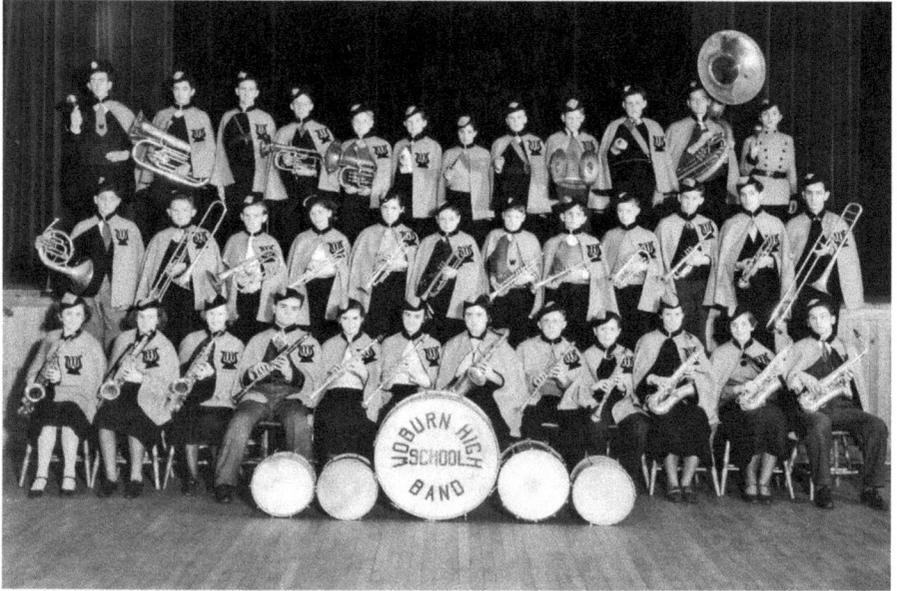

The 1934 Woburn High School band. *Woburn Memorial High School archive collection.*

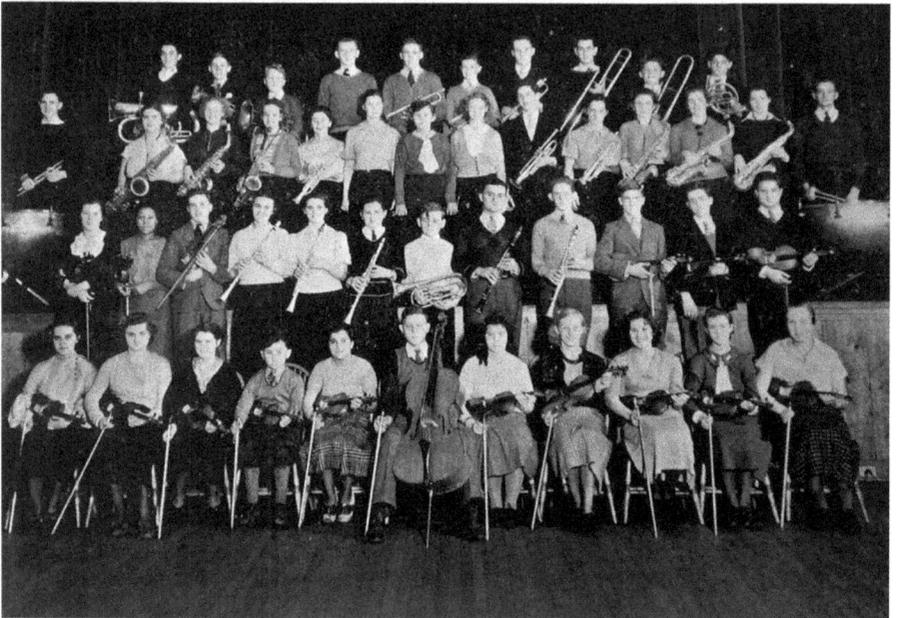

The 1934 Woburn High School orchestra. *Woburn Memorial High School archive collection.*

Fishman Kaye, class of 1934, recalled: "I was involved in every phase of music activities as pianist for the orchestra, chorus, glee club. I also had a part in the senior play *The Restless Jewel*." Bess Zimbel Fleishman, class of 1936, reminisced, "I spent four years appearing in all the operettas, even solo, singing during my class graduation."

Sidney J. Paine, class of 1930, described the military ball as one of the highlights of the year:

> *In the midst a blaze of lights and a riot of color the Woburn High School battalion officers staged their eighteenth annual military ball at the Woburn Armory. The ballroom was draped in yellow and white bunting with American flags. The grand march was the feature of the evening and was staged immediately after the introduction of the patronesses. The ball is always considered one of the most brilliant high school balls of the state. Woburn is the only high school that adheres to the formality of introducing the guests to the patronesses.*

The round table club consisted of students who represented every organization in the school. They promoted high moral standards and discussed topics of too much noise during filing, a larger supply of wastebaskets, sufficient sandwiches for late arrivals, a larger variety of sandwiches on the boys' counter, cleanliness and neatness throughout the school, model manners at all times and who broke milk bottles during recess.

The *Reflector* was a wonderful voice for the students, as Phyllis McClure, class of 1934, wrote, "I wonder if we make the best possible use of our study periods. During the course of a week we do not find as many seniors wasting time as sophomores. Those of us who still have a year or two of high school left might well learn a lesson from this. If we do the very best we can from day to day, we shall not find ourselves, near the end of our senior year, rushing around on the verge of tears, looking for a sufficient number of points for graduation." Harriette Fowler, class of 1934, spoke of school spirit: "Just what does the term school spirit embrace? Loyalty, honesty, sincerity, and obedience. It includes all the so called virtues of daily living anywhere and it has various aspects. Without these four fundamentals, no one would care to attend a school, no matter how superior the teachers or how fine the buildings might be." Dorothy Sinton, class of 1933, added, "Pride in ourselves and our schools is a valuable motto. We must stand up for our school and we have the right to be proud. It's ours as much as it is the other fellows." Betty Parshley, class of 1935, remarked,

At present, the thrills of the coming senior reception are foremost in our minds. To think that at last we are the ones who are to be the central figures at this the greatest social event of the years, fills us with joy. After the reception comes class day, the last day we will spend informally together. At that time we will review the many happy and worthwhile incidents that have occurred during our sojourn here. We will play those small jokes on one another for the last time. In all this happiness there will be will be intermingled a note of sadness. The last event of our school life is our graduation exercises. Thus our last days together will pass in a whirlwind of merriment and excitement.

Listed in the 1936 school archive book, one of the most memorable fundraisers of this decade was the "basketball on donkey back" game. On Friday, March 27, 1936, for a thirty-five-cent admission, one could watch teachers and students play basketball on real donkeys. The teachers defeated the varsity quintet in a basketball comedy in the school gymnasium. The rubber-shod donkeys were led onto the court of combat with given names like Mae West, Al Capone and Lazy Bones. The book stated, "Both

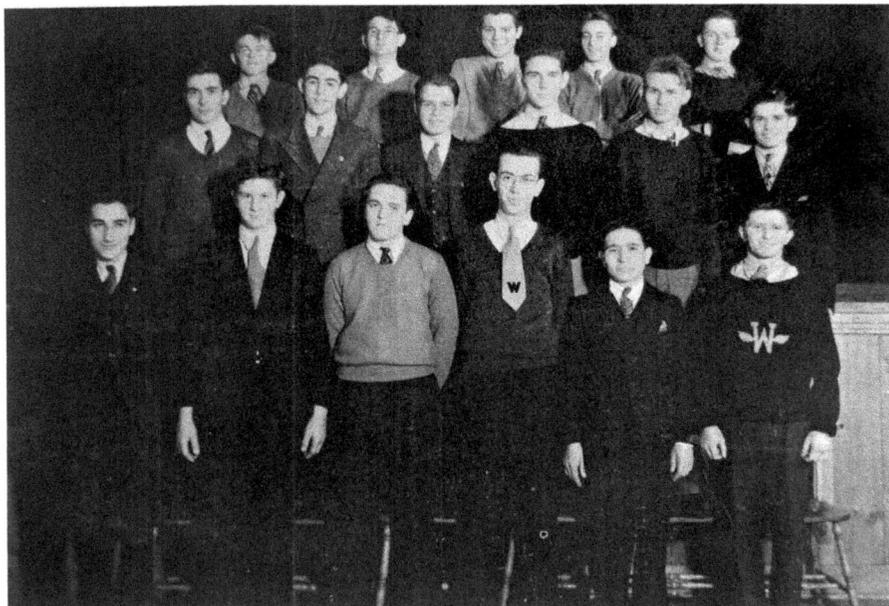

The 1935 traffic squad. *Woburn Memorial High School archive collection.*

teams were costumed for the occasion and their initial appearance on the cover was the cause of an outburst of laughter. The balking and bucking of the donkeys along with the frequent spills, head on collisions and the characteristic cussedness of the cutters added to the hilarity of the evening and when one individual on the faculty embarrassingly lost his pants, the gymnasium rocked." Seventy years later, Ray Ross, class of 1939, recalled being at the game and enjoying the event.

The Junior Rotarian program was established in 1933. "The two most manly and most energetic boys" would meet with the Woburn Rotary at regular luncheons every Tuesday. This was an opportunity to rub elbows with local business owners in a professional manner. The traffic squad continued to have an important presence in the hallways, as the all male leaders monitored student traffic flow, behavior and conversation. These fine young men were honored to patrol the hallways as officers.

ATHLETICS

Students started to have tremendous pride in their athletic teams, as expressed in the *Reflector*. Everett Peterson, class of 1934, declaimed, "Orange and Black, thou colors of might, wave on right freely from morn till night, envy thou not the stars of the sky. Nor wish thy banner could fly as high." Harold Callahan, class of 1931, noted, "As I stood on the side lines the other day, and watched our team go though their plays, I began to wonder why the fans on the stand which consisted of boys and girls and the band were so determined we should get a goal so they could yell for their own school. It must have been contagious for they all did share it. So let's join them and catch that school spirit." Bernard McGuerty, class of 1939, wrote, "School spirit also means more than being a good scholar. It means an attitude of friendliness and helpful cooperation toward other students."

Irene Scott, class of 1931, reported, "Field hockey is more popular this year than ever. The interclass games and encouragement of large numbers will help the effort in the development of a varsity team." The school established the first cheering squad with four cheerleaders: Madeline Haggerty, Loretta Gorman, Lorraine Tessier and Grace McCauley. Class of 1933 member Robert Smith spoke about track:

> *In former years track was a major sport in Woburn. Track meets received as much publicity as any other sport and Library Field always boosted*

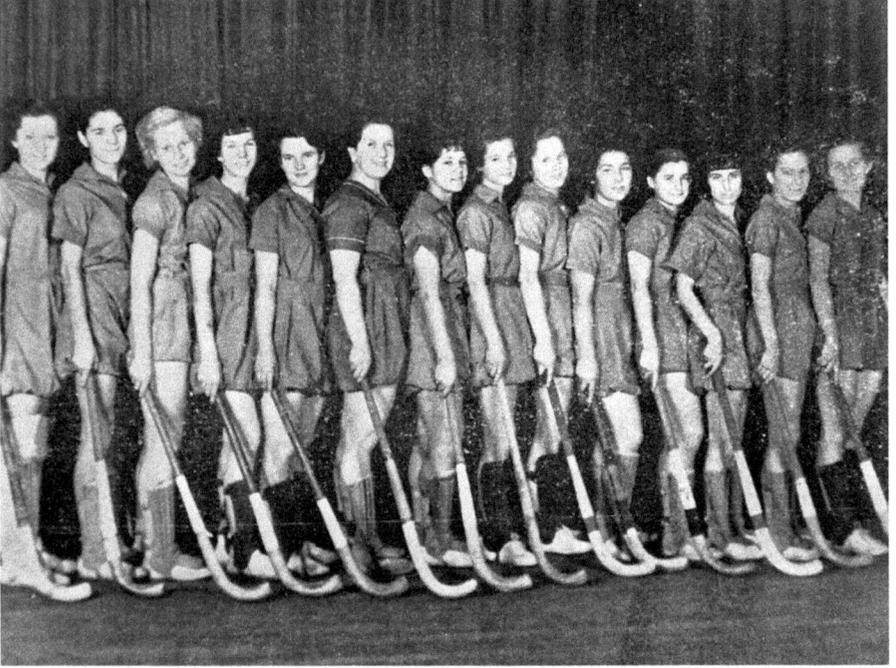

Pictured here is the 1936 field hockey team. From left to right are Betty Cronin, Ethel Hardy, Alice Anderson, Lillian White, Ruth Smyth, Ethel Hogan, Athena Varoutson, Nellie Cappozola, Helen Rosander, Aldora Crawford, Gladys Flaherty, Rose Signorello, Eleanor Dulong and Ruth Franson. *Woburn Memorial High School archive collection.*

track meets. Thousands of spectators gathered to cheer the local aspirants to victory, and runners from all corners of the state came to participate. Then for some reason, track was neglected. However, it has been reestablished and few of us who have attended the meets have become vitally interested in that form of sport.

John Gillis, class of 1930, stated, "Among the things that were supposed to accompany the building of our present school was a field but there are no signs of it. Each spring the teams gather at Fleming Field to practice because Library Field is never in a condition for baseball at this time since the field was once a swamp and does not absorb water. Fleming Field is very rocky and short and so is Library Field when it is prepared. Woburn has always been famous for its baseball teams so let us hope we get a field." The 1930–31 hockey team had a winless season and marked the start of a twenty-four-year layoff for the program. There have been several stories

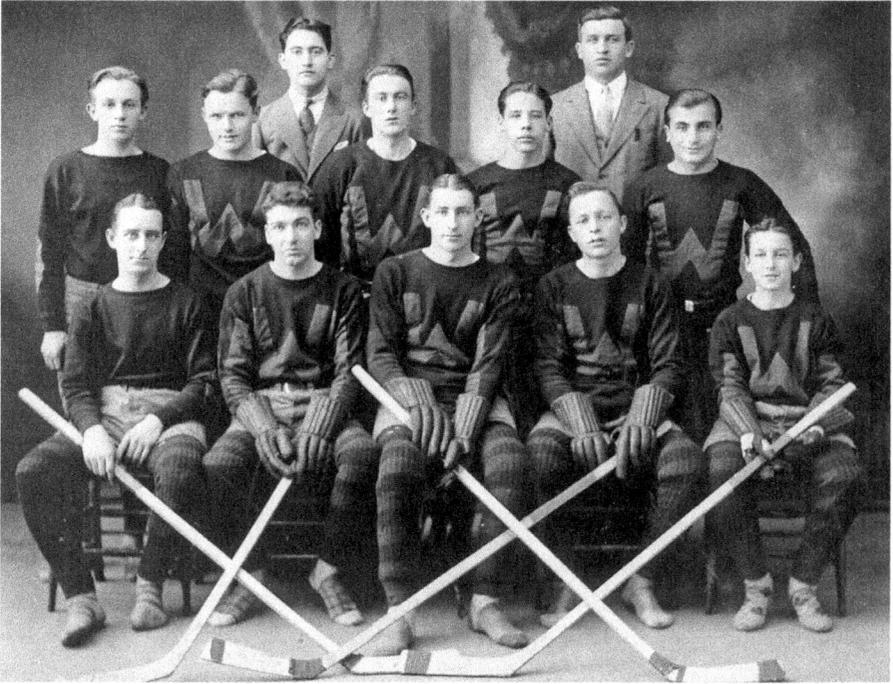

Pictured here in no particular order are members of the 1930 hockey team: Jerome Cronin, Ed Canney, Patsy Debenedictus, Festy McDonough, Bob Smith, Skipper Connolly, Tom Foley, John Buttimer, Wilfred Walsh, Charles Murray, Hugh Queenin and Bill Paine. *Author's collection.*

about why hockey was eliminated, including the Great Depression, ice time and weather conditions for outdoor playing.

FUN FACTS

- The average yearly expenditure per pupil in 1935 was $88.64.
- The high school was the headquarters for the dental clinic office.
- Mr. Bean issued the following color schemes: red for dunces, yellow slip for out of place, white slip for library and blue slip for teacher summons.
- Rifle club was formed in 1930 and became popular due to military drill.
- Spelling bees were popular in 1939.
- Tux rentals cost $1.50.

- Local stores included Callahan's ice cream. O'Brien's Pharmacy, Tabbuts Dairy Milk, Tanners National Bank, EG Barker lumber Co., Silverman's and Woburn Five Cents Savings Bank.
- Every class had a know-it-all, pest, poor sport, flirt who giggles, town crier, troublemaker, sociable favorite, class clown and tomboy.
- The school radio program broadcasted music by the orchestra.

TRADITIONS

The Story behind the Junior Prom

The class of 1934 held the first ever junior prom on Friday, April 28, 1933, in the school auditorium. This successful junior prom actually took the place of the military ball that was popular for many years. Joyce's Orchestra provided the music for the evening, and students danced from 8:00 p.m. to midnight for a ticket price of forty cents per person. The evening was described in the *Reflector*: "The hall was beautifully decorated in pink and green and an archway was trimmed with pink carnations and snapdragons which made a charming setting for the matrons." Today, the junior prom is held in the month of April and is considered the first formal event held outside of the school at a local venue. Girls shop many months in advance for the perfect gown, boys rent tuxedos and sometimes limousines are hired for the evening. The approximate cost to attend per person is seventy dollars, which includes music provided by a disc jockey, dinner and dancing.

1940–1949

Impact of World War II at School

Tomorrow is graduation day. Some of our classmates will not be able to attend the exercises because they are far away fighting for the liberty which we all love and cherish. May God speed the day when the war in the pacific is over and they can all return to their homes and loved ones.
—Mary Wagner, 1940s student

World War II had an enormous impact on the city due to the sheer number of young men who went to war. The war dominated most of the 1940s, and along with the lingering limitations of the Great Depression, Americans really struggled. The importance of education was instilled in many homes, especially as many young men were going to war. Thomas Pecora, class of 1940, discussed this: "I took the general course and it allowed me to go to college if I wanted too. I went into the war after high school with everyone in town but I ended up going to Boston University after the war. Getting a good education in high school allowed me to go to college after the service. A good education helped open doors for me to go to college and have a successful career." The limitations of the Great Depression affected Mary Ferullo Mills, class of 1940: "During this time, the city was divided into sections. My mother learned to make bread because the purchase price was five cents and there were many bread lines. We probably had three outfits to wear and a Sunday outfit for church. We would wash clothes with a wringer and then hang them on the line. The big difference with today's generation versus when I grew up was we were satisfied at what we had; today they want more. Years ago, we were happy or lucky to have pen and paper. You were

considered poor if you came to school with sneakers and dungarees." Mary also discussed the role of girls in many families: "I worked at Gorins and my brother, Jackie, worked with me. I had to be home by four in the afternoon. I had a strict upbringing in the village in North Woburn. Everyone had to be home for supper at five. The boys played sports and the girls worked at home. You were lucky to go to high school. So many friends did not go. The oldest girls always did the helping with the family." In Woburn, four hundred men had enlisted by the time the attack on Pearl Harbor occurred. This event had a profound effect on the schools, as Superintendent Daniel P. Hurld wrote in the 1942 annual report: "It is not possible at this moment to write this discussion without saying that the present world condition has had an effect upon our entire student body, particularly the older students. War and its glamour affect us and continue to be a discussion on the radio and disturb a mind at educational talks." Consequently, for the first time since World War I, the national draft registration began.

This decade was also known as the "fabulous forties" due to the country coming together for one cause; people possessed a strong work ethic and displayed genuine camaraderie. Lifestyles began to change, as TV dinners, Tupperware and a new device called television were welcomed into homes. Students in high school were no longer referred to as adolescents but by a new popular term: teenagers. These teenagers hung out downtown, as described by Ray Ross, Class of 1939: "The busy bend corner is where we hung out. They closed that section of the street off on Friday nights. All the guys would stand on the corner and sing 'standing on the corner watching all the girls go by.' We also went to Barney Callahan's for ice cream. Back then, you were friends with everybody, you would take people as you found them and I found some pretty good ones." Helen Franson Jonsson, class of 1941, reminisced, "Frankles near the Strand Theatre had a place upstairs where kids had sodas and frappes. We would go to the Strand Theatre once a week for ten cents and we would sit there all afternoon and watch the news report, two full movies and coming attractions." Marilyn Mohan Ryan, class of 1945, also enjoyed going to the movies and spending time downtown. Bernard Walsh, class of 1943, recalled, "We walked everywhere, we crossed the tracks to school. Kids would walk from Shannon Farm on the west side to school, that is a long hike from that Lexington Street area. I sold *Boston Record* newspapers to thirty-three barrooms. The train would come in from Boston and I would start in the South End to deliver them all. It was hard work."

FACULTY AND STUDENTS

Principal Bean's steady leadership role under these uncertain conditions was important. In the 1941 annual report of Woburn, Superintendent Hurld directed efforts after Pearl Harbor, sending pails, shovels and lanterns to all schools for use in the event of a bomb strike. Committees were formed for protection of school pupils and property. Directions were given on how to handle incendiary bombs and how teachers should conduct themselves in any crisis. Several teachers were enlisted in the armed forces, and there was an uneasiness among the boys, many of whom were greatly concerned about their immediate futures. Teachers took courses in civilian defense, prepared for regular air raid drills and conducted Selective Service registration. There was sugar, gas and fuel rationing, and students became very involved, participating in war savings programs. Equipment purchased by the school war loan drive included a jeep, life float, field ambulance, trailer, parachutes and tank ammunition. The Junior Red Cross sold Christmas seals. All of these efforts showed a real spirit of patriotism and cooperation from the young people of the community. In 1946, Hurld retired, and Frank J. Hassett became superintendent of schools.

Student Frances McGann wrote, "The Class of 1942 is the first class to be graduated from Woburn High during World War II. It is indeed likely that many of the members of this class will be called upon to defend our country in its greatest hour of crisis. It is also likely that some of our classmates will give their lives in defense of their country." Robert Dobbins, class of 1946, expressed in his valedictorian speech, "Unlike preceding graduation classes, we are the first to graduate from this so called Atomic Era. Whether or not this new discovery of potential energy will revolutionize the future being of man is a question which only posterity can decide." Donald Fowle, class of 1946, commented, "Today with so many positions lying open in factories, stores, freight yards and offices throughout the country there is a great temptation for boys and girls of high school age to leave school and fill these vacancies. This temptation has already succeeded in seducing too great of a part of our youth from places of education. It is evident that the future of educational advantages will far outweigh the little extra money earned at the present time."

The importance of an education was valued by so many students. Dorothy Weafer, class of 1944, advised, "Do not forget those who are helping you to receive this knowledge, your teachers. Appreciate them and be thankful to them for not until later in life may you fully understand the value of the

lessons they are now teaching you." James Murray, class of 1949, stated, "Don't be afraid of your teachers. They are only too glad to help you. They want to see you get along well in school. They will try to help you if you'd only ask them." Lorraine Peary, class of 1946, wrote, "Tonight when you reach to pick up the telephone to carry on an endless conversation with your best friend, or turn on the radio to hear a super story, stop first, turn to your books, consider the rewards, make your decision, and remember: anything worth having is worth studying for."

According to the school archive book, women teachers suffered from a series of gender inequities well into the 1940s and had to resign once they married. In 1942, teacher Ruth Preston left the school ahead of her upcoming nuptials. Married women were often barred from the classroom because they were of childbearing age, and that was not acceptable in the school system. Things started to change during World War II, and the gender discussion was disrupted when women went off to work in factories and assembly lines in place of the men going off to war.

ACADEMICS

According to the 1947 Annual Report of Woburn, the business department had an increased class load. Mary Ferullo Mills, class of 1940, discussed her schoolwork: "I took typing and shorthand because I knew the boys in my family were the ones who got the education. If you didn't go do the college course you took typing and shorthand courses so you would get a job. My father used to say that the four boys had to go to college first. He said that the boys earned a living, women stayed home. I decided when I had my three daughters I wanted to break the chain and send them to college." The school curriculum was enhanced with new courses in safe driving, preflight aeronautics and an updated physical education program. The Rinehart Functional Handwriting System was required for all students. The school committee voted in 1947 to excuse all boys from taking physical education if they were members of a school athletic team but only during the season that they played on a team. Due to a large percentage of students who married after graduation and needed homemaking skills, additional home economics equipment was purchased. By 1946, a guidance department was in full operation, and the objective for the first year of operation was to counsel seniors about future decisions.

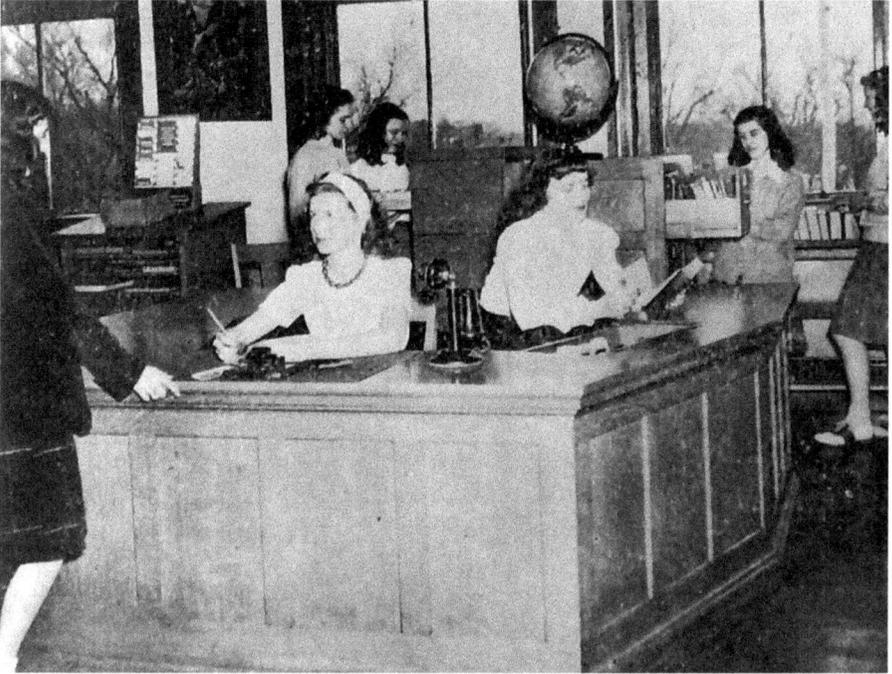

Harlow Library located in the high school in the 1940s. *Photograph by George Zimbel, Woburn Memorial High School archive collection.*

The Harlow Library was considered one of the most outstanding scholastic libraries in Massachusetts. The staff and students were very fortunate to have this resource located in the building, since very few schools in the area possessed libraries, and many contained only reference and encyclopedia volumes.

Barbara Ann Erwin, class of 1947 valedictorian, expressed her sentiments about school on graduation day: "Classmates, we must now turn to each other and say farewell for this is the last time that we shall meet together as the senior class. We had many unforgettable times together which we shall always treasure in our memories." Patricia Campbell wrote the class song in 1946: "We will be guided by thy love, Woburn High, dear Woburn High and loyalty to thee we'll prove, Woburn High, dear Woburn High. We will remember every year spent in this school of ours so dear, and now we leave with parting tear Woburn High, dear Woburn High." Helen Paicopolos King, class of 1943, reminisced, "High school is where good memories were made. No one moved away, you made connections and there was a closeness with kids since first grade because families grew up together."

ACTIVITIES

The student council was established in 1946 to promote school activities and foster a spirit of responsibility, leadership and personal growth. Students were nominated and voted in during their homeroom period. The music department program consisting of chorus, orchestra and band was very popular and drew large numbers. The art department also was a favorite of students, as it supported many school events by printing tickets and programs. Florence Salvati Cryan, class of 1949, recalled that some of her favorite memories of high school were "Friday night basketball games, Saturday football games and going to Barney Callahan's after school every day for a vanilla coke. Girls wore plaid skirts with a pin and brown-and-white saddle shoes. I have many friends which I still enjoy and we had so much fun and happy memories." Barbara LaCasse Rafferty, class of 1947, said she still has dear friends from high school and enjoyed football games, the Spa (a local soda shop) and the prom in the old auditorium.

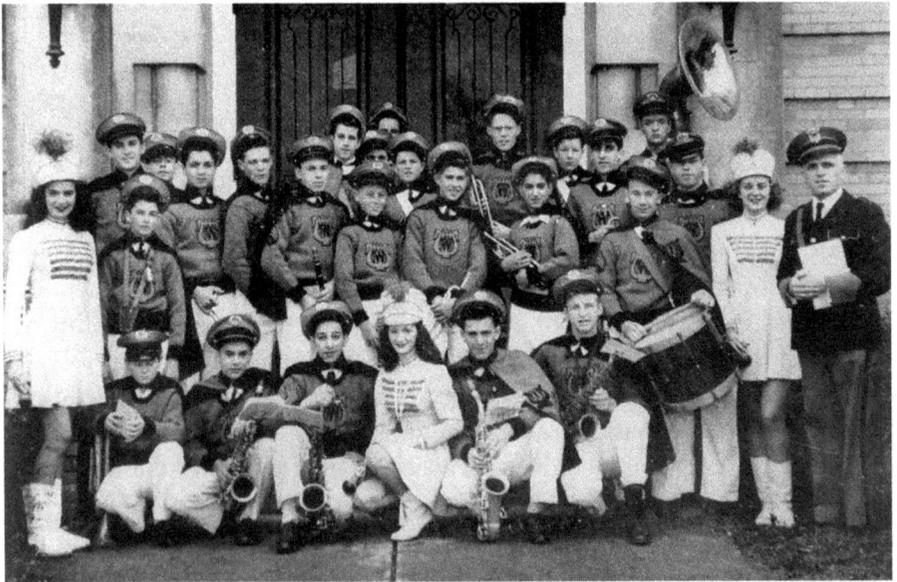

Pictured here with Mr. Edson Kimball are the 1947 marching band and majorettes. *Woburn Memorial High School archive collection.*

ATHLETICS

The athletic programs continued to expand and began to have a prominent role in the school culture. Sports were considered extracurricular activities and no different than academic studies in the sense that they were part of the educational experience of youth. The school colors of "orange and black" had been spoken and written in this order until sometime in the mid-1940s, when the order changed to "black and orange." These colors were reflected in uniform styles and the many celebrations that accompanied victories.

The field hockey team and boys' cross-country teams were reestablished, but the absence of an ice hockey team was felt since its departure in the 1930–31 season. There were Mystic Valley Championships for the 1940 track and football teams. When the Mystic Valley League folded in 1943, the football team played as independents, as did the boys' basketball team, which had several winning teams during this decade.

Victory dances were popular, and the 1940 school archive book described one such celebration:

A victory dance with Winchester and Woburn students was held on Wednesday, November 19, the night before Thanksgiving. The cheerleaders

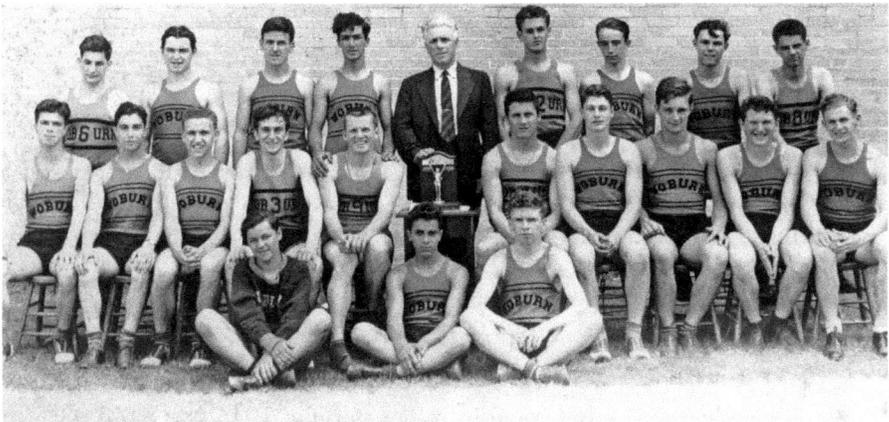

The 1940 Mystic Valley track championship team. From left to right are (first row) James Campbell, Peter Pappas and Charles McGuerty; (seated) Nicholas Kreatsoulis, Andrew Prousalis, Paul Logue, Joseph McCafferty, Larry Cullen, Robert Roche, Richard Cavicchi, William Brewer, Edwin Crouch and Edward McCall; (standing) John Pandolph, Chris Clancey, Herbert Reardon, Charles Stamatis, coach John McGovern, James Lichoulas, George Bacon, George Roesselor and Donald Johnson. *Photograph by R. Mitchell, courtesy of the Edward H. and Daniel L. McCall family foundation.*

Cheerleaders pictured here in 1947 are, from left to right, (first row) D. Brock, C. McGovern and J. Fenton; (second row) E. Rice, I. McCue, V. Foster, M. Sweeney, E. Foley and P. Mohan. *Woburn Memorial High School archive collection.*

led the crowd with several cheers for their teams. Several awards were given out during the evening including tickets to the Totem Pole Ballroom, Keith's Theatre and prizes from Larry Murphy's and McCormack's Drug Store. Six hundred students attended the dance which was held at the high school auditorium from eight to midnight for an admission price of forty-four cents. A good natured spirit of fun prevailed all evening and though it was on one of the quietest nights before the big game, it was one of the most enjoyable. Music was furnished by Crandall Courtney and his orchestra.

FUN FACTS

- The average yearly expenditure per pupil in 1945 was $118.93.
- All pupils had to have chest X-rays.
- The school health program plan began to examine the teeth of all children.
- No school signal was heard from the fire department, Atlantic Gelatin, Consolidated Chemical Company or Riley's Shop.
- Best posture awards were given to students.

- A sick-leave policy was adopted for faculty in 1949.
- The 1946 senior class outing was at Nantasket Beach.
- Athletes were insured against injury for $500.
- Boys and girls did not sit at lunch together.

TRADITIONS

The Story behind the Yearbook

The class of 1947 published the first yearbook for the school and named it the *Innitou*. The name was derived from the legend of the great spirit Manitou, who liked to gaze at his reflection in the clear waters of Lake Innitou (now know as Horn Pond). In keeping with the legend, the yearbook permits seniors to "reflect" on their many high school memories. The school archive book recorded that the yearbook was presented to seniors and honored

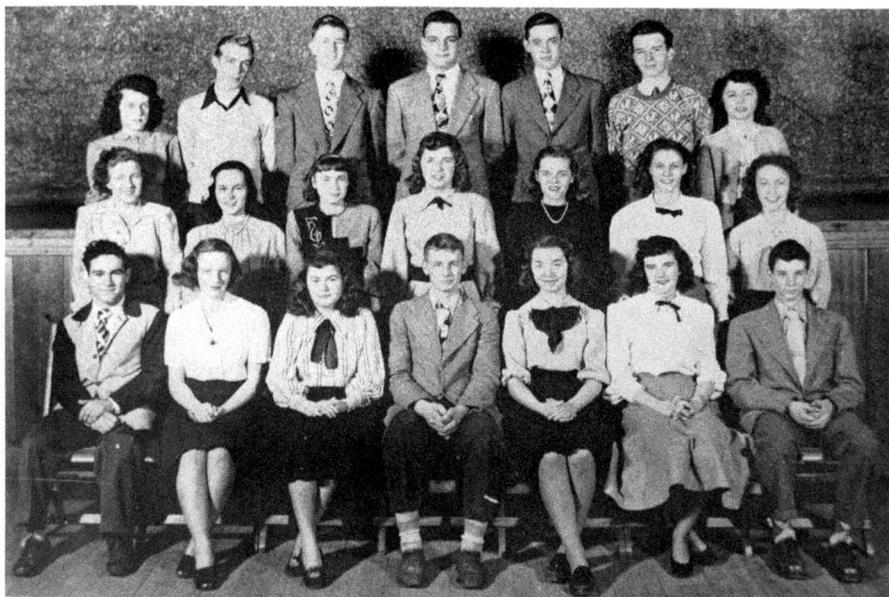

The first yearbook staff, established in 1947. In no particular order are Madeline Coccoluto, Dana Brown, Elizabeth Fallon, William Heimlich, Walter Ekland, Clayton Lacy, Margaret McCafferty, Ruth Marshal, Marjorie Norton, Thespina Trianfilou, Judy Bemis, Donald Brown, Donald Everberg, Rosalie McGuerty, Anthony Sgrulloni, Claire Harrington, William Weafer, Winona Baird, Leonora Brogna, Jeanne Morgan and advisor Margaret Burke. *Woburn Memorial High School archive collection.*

guests at the first yearbook banquet in the auditorium. "Interest throughout the city ran high in this project all year and was climaxed on the last Tuesday, when the pupils saw their effort consummated in a volume which reflects a high degree of credit on the staff and advisors." The banquet was one of the highlights in the commencement activities. Today, the yearbook is designed on computers with a dedicated staff volunteering their time to preserve their class memories. The staff has received numerous awards over the years, including National, Best in New England and Showcase Awards. Yearbooks are presented to the seniors on Class Day at a ceremony consisting of speeches, recognitions and video presentations.

1950–1959

A Generation that Loved Going to School

We were a family, taking part in all experiences together, making memories to last a lifetime, and all under the umbrella of our high school days.
—*Judith Powers Golden, class of 1959*

Teenagers were altering the face of American culture across the country with bobby socks, loafers and dungarees while parents were changing the way families valued education, as they insisted that their children graduate from high school, go to college and achieve a higher education. They did not have that opportunity for themselves, as they had seen the adverse effects of the Great Depression and two world wars. The prevailing mindset of a career ambition for girls after high school was to be the perfect wife, secretary, nurse or teacher, and boys' career ambitions were to graduate from college and work full time as managers, engineers or business owners. The husbands were the breadwinners of the family and not responsible for any household duties, while the life of a wife was centered on home and children. School curriculum and activities supported this lifestyle, as the future teachers and future nurses clubs became popular, along with homemaking, fashion and sewing classes.

This generation loved the comfort of going to school and knowing that their friends would always be there at their second home. Victoria Woods Massaro, class of 1957, commented, "I think the older generations were closer because everyone didn't have cars and we shopped and hung out downtown. We grew up playing in our own backyards." Students bonded in high school more than ever because they felt school was their home away

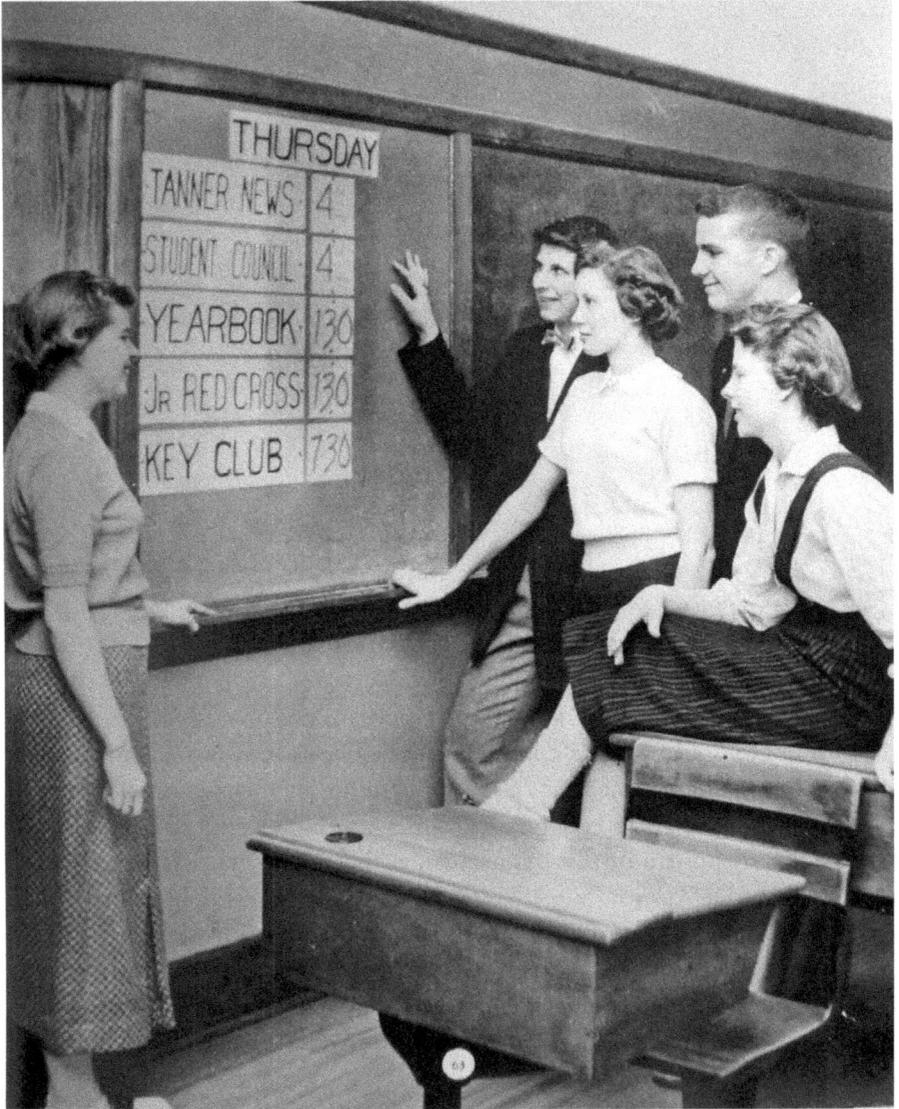

Students discussing the week ahead and planning their club activities. *Woburn Memorial High School archive collection.*

from home. The neighborhoods were an intricate part of teenagers' lives, as they walked to their friends' homes and worked at local shops such as Bond Shoe, Marion's Dress Shop, Gorins and Newberry's. They hung out at places called the Spa, a small shop that served soda, chips and cherry or vanilla coke; Barney Callahan's ice cream shop; and the Strand Theatre.

Knowing their friends would always be there, students relax outside the school in 1959. *Woburn Memorial High School archive collection.*

James Haggerty III, class of 1956, shared his thoughts: "It's all about the community, everyone got along, it was a great experience with great people." The neighborhood, community and school were opportunities for them to be social and build strong friendships, some that were formed as early as elementary school and lasted a lifetime. Families many generations deep were invested in the school, including Bill Lindquist and Joan Govostes Lindquist, class of 1959, who had parents, brothers, sisters, aunts, uncles and children who attended. Teenagers became independent and started to make their own decisions, especially in regards to the music they listened to, which ranged from Frank Sinatra to Elvis Presley and from the cha cha and swing to rock 'n' roll. Paul Everberg, class of 1955, recalled, "We had a jukebox in the cafeteria that brought pleasure to students while having lunch. I remember the song 'Santa Baby' by Eartha Kitt was deemed a 'little too earthy' and was yanked out of the jukebox by the school administration!" The YMCA, located on Main Street across from Kilby Street, hosted many dances for students for an admission price of twenty-five cents. This was among everyone's favorite places to be on a Friday or Saturday night.

The population of Woburn exploded, along with that of the rest of the country, as an overwhelming number of babies were born. These baby

boomers were born into families where the average number of children was five or more. Many of the local farms were sold and developed for new homes, and that led to new elementary school buildings being constructed. Woburn became the perfect location to live due to its proximity to the new Route 128 that was completed in 1951. The city also experienced a fire at St. Charles Church in 1951 and two major hurricanes in 1956.

FACULTY AND STUDENTS

Principal Bean retired in 1951 after an unprecedented thirty-five-year reign. According to the 1950 school archive book, he witnessed many changes in the school and community, two wars, contract negotiations, the establishment of a junior high system and the 1930 additions. He was a mild-mannered man who valued discipline and always supported his faculty. On occasion, he would walk to school from his Sherman Place residence, which was only steps away from his second home of Woburn High. Bean arrived in Woburn at the age of twenty-eight and will always be known as a Woburnite since he was an integral part of the school and community. The school administration did not have to look far for Bean's replacement, as it voted in forty-year-old Henry D. Blake, a former Woburn High English teacher. Blake was a 1928 graduate of Woburn High, attended Yale University and served as an officer in World War II. His vice principals were Lawrence Gilgun, class of 1948, and James Brennan, class of 1935. Blake embraced his new role as he addressed the students on the first day:

> *It is a pleasure to welcome you back to Woburn High School. The beginning of a new school year is a challenge to your ability, your interests and your school citizenship. Your teachers, the guidance department, and your principal desire to assist you in every way. As you begin your tasks today, resolve to offer your best in the search for the best obtainable educational preparation for your future careers.*

Blake revised the program of studies to include graduation requirements, scholarships, a marking system, course selection and extracurricular activities. The curriculum included social studies, commercial studies, English, chemistry, math, biology, bookkeeping, accounting, Latin, French and aeronautics. He also instituted a strict dress code. Annette Coccoluto, class of 1957, recalls,

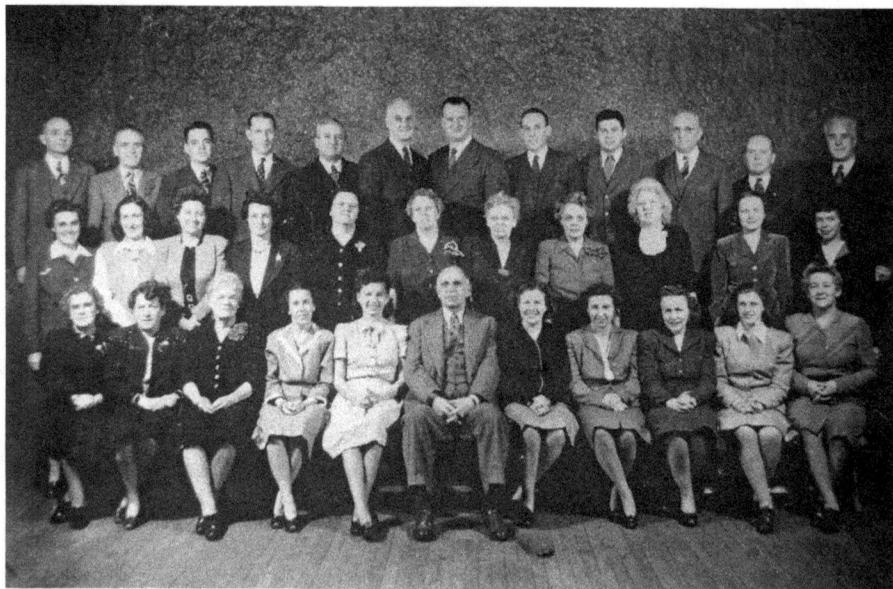

Faculty in the 1950s. *Woburn Memorial High School archive collection.*

"Boys wore dress shirts and girls could not wear slacks or dungarees." Rita Abreu Doherty, class of 1955, also commented on the fashion of the day: "Mid-calf skirts, blouses, crew-neck sweaters, white buck saddle shoes and Adler socks."

In 1959, the school committee selected a dean of girls and department chairs in English, math, science, language, social studies and commercial studies. Teachers were highly respected, and students had appreciative thoughts. According to Paula Kendrick Fabello, class of 1959, "My memory of the teachers and faculty was all positive. I had some excellent teachers. I developed many friendships during my years at WHS and have always felt a strong connection to Woburn High School, largely because it represented a very happy time in my life." William Jaquith, class of 1955, also recalled that he received good grades in order to enter a competitive college. He especially thought the labs were good and continues to have an interest in history thanks to his teachers.

The 1952 school committee voted on a new prayer to be recited each morning by teachers and pupils as part of opening exercises: "Almighty God, creator of all things and from whom all good proceeds, we humbly acknowledge our dependence upon thee, and we beg thy continued and constant blessings upon us, our parents, our teachers, our government,

our country, and all the world." In the early 1950s, hysteria over a perceived threat of the rise of communism in the United States became known as the Red Scare. Woburn was not immune to this fear, and according to the 1954 annual report, all school employees had to take a "loyalty oath" renouncing communism. This oath pledged allegiance to the U.S. government.

The policy of refusing to hire married women continued throughout the 1950s, as evidenced by the 1953 annual school report:

> *It has been found that young married women teachers need every second or third years off to have their children and additional time off to take care of them when they are ill. The older married women whose families are all grown up find that they are not familiar with modern methods, techniques and procedures in teaching as they have not taken any educational course in twenty years. In either case, the policy of hiring married women for permanent teaching positions has not worked out well in many communities in which married women are hired.*

ACADEMICS

The 1956 annual report of Woburn references its commitment to education: "The school stands committed to meet the challenge of the complex demands of the mid twentieth century by striving to provide the best possible preparation for all youth. Economic and technological advances of the past century have compounded the challenge. The educational needs of youth have far more greater opportunities and offerings." Paul Everberg, class of 1955, believed "that most former students realized at some point, that while attending Woburn High, they were provided the basic tools needed to be successful in life. Many of my classmates who applied themselves were adequately prepared for college, were accepted into institutions of higher learning and went on to enjoy very successful careers." The gender gap continued in some courses, as only boys were allowed to take courses in pre-chef food preparation, industrial arts, woodworking, electrical shop and the audio visual programs that consisted of motion pictures, radio, television, tape recorders and film strip. The girls elected physical education classes that offered square dancing, running, skipping and posture drills.

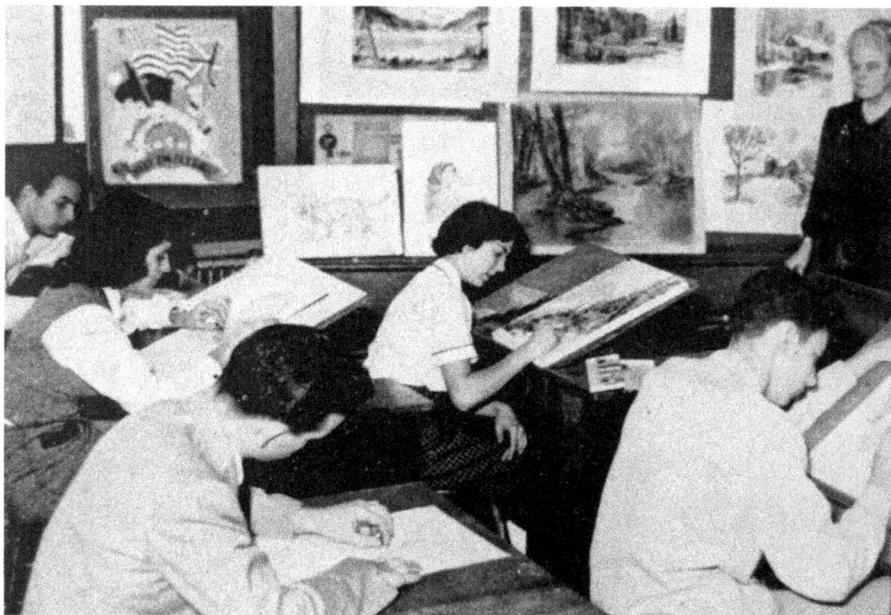

Artists at work in the art room, 1958. *Woburn Memorial High School archive collection.*

ACTIVITIES

By becoming a member of a club, students were able to make new friends, volunteer and become well-rounded individuals. The school offered an abundance of activities that supported this philosophy: band, orchestra, drum majorettes, glee club, thespian society, traffic officers, student council, *Tanner News*, Junior Red Cross, drama, radio club, pep squad, future teachers club, debate team, National Honor Society and bowling leagues, all contributing to the success of the student. Community organizations within the city contributed to the school by sponsoring clubs for students to be active in the community. Kiwanis Club (Key Club), Woburn Host Lions (Leo Club) and Rotary (Junior Rotarians) were some of the early clubs to be involved.

According to the 1950s school archive book, a new type of entertainment was started in 1958: the Black and Orange Revue. This unique event was the social affair of the year—a combination of a musical and variety show presented by students as a fast-moving production. The show was directed by William Flaherty, with music provided by Lawrence Gilgun and assisted by many faculty members. Traditions and formalities of the proms were recalled by Peter Carbone, president of the class of 1959:

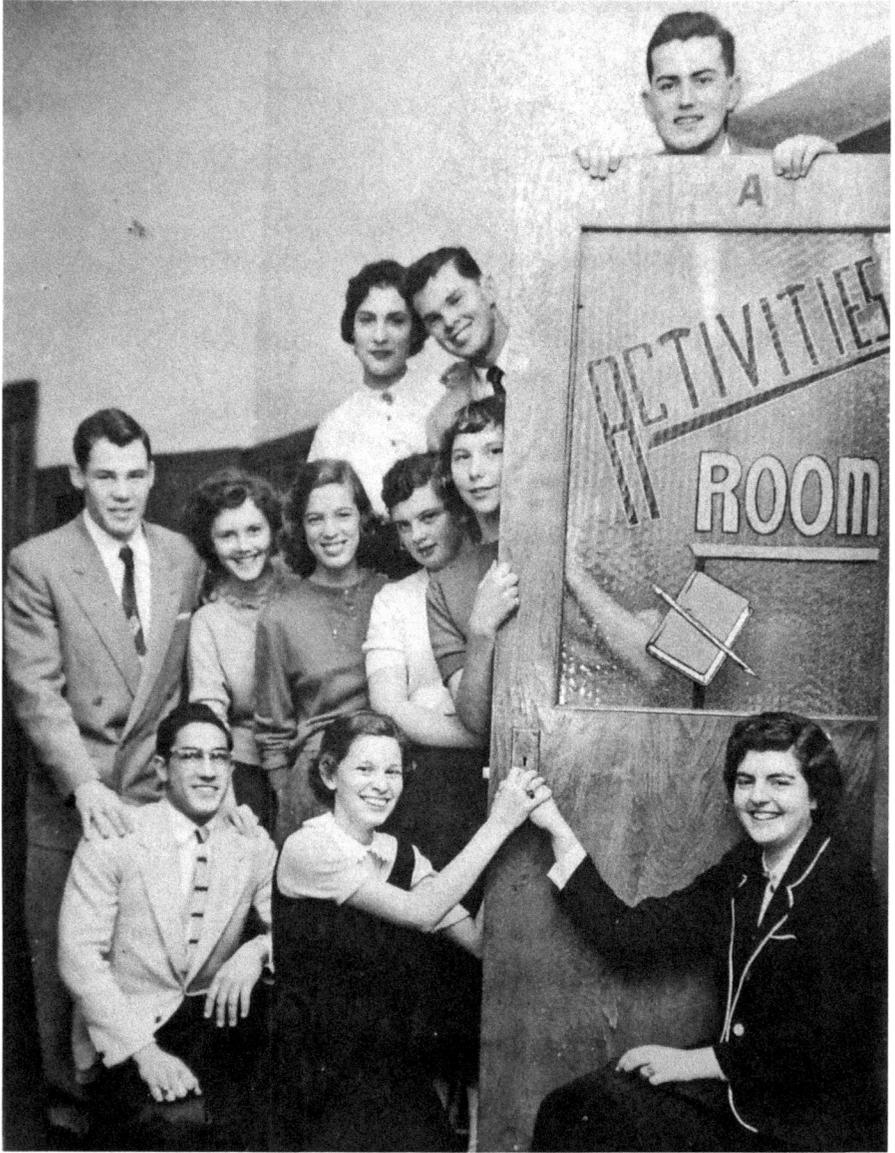

The 1956 activities committee getting ready for a new school year. From left to right are (first row) Lewis Deluca, Myrna Masse and Joan Balestrier; (second row) Joseph Upton, Marilyn Little, Mary Danforth and Shirley Knowland; (third row) Josephine Ciampa, John Marlowe and Richard Canniff. *Woburn Memorial High School archive collection.*

The famous grand march tradition. *Top*: The entire class marches in. *Bottom*: (first row) Carol Zubel, Peter Carbone Jr., Linda Cogan and Neil Odoms; (second row) Linda Erikson, Tom Gibson, Janice Higgins and unidentified; (third row) Alice Carney. *Above, Woburn Memorial High School archive collection; below, courtesy of Carol Zubel Carbone and Peter Carbone Jr.*

We had a receiving line at the beginning of the prom, where class advisors, class president parents, and teachers would shake hands and greet everyone going through the line. As president, I would start the grand march by going down the middle of the old auditorium floor with my date, then the other officers would follow. Each would walk down as a couple, and we would break off to the right and the next couple to the left and we would circle around to the back of the room. Now, there would be four of us that would walk down with arms linked and then two couples would break off to the right and two to the left. Circle around again, now you have eight people coming forward. You kept doing this until the whole class breaks off into six rows. The whole auditorium would be full with everyone linking arms together.

Judith Powers Golden, class of 1959, recalled her favorite memory:

I have many memories of my high school days, but the first one to come to mind is the one of my graduation. This was the last time I would be a high school student, and I didn't want school to be over. I loved it and realized that it would be the end of my relatively easy life; not much to worry about, just what I had to study, what to wear, where to go after class, etc. From

Seniors leave an assembly in the old auditorium in the 1950s. *Woburn Memorial High School archive collection.*

now on, I would be an adult with all the responsibility that that implied. I would be leaving familiar territory, friends and activities.

Carol Erwin, class of 1956 salutatorian, spoke at graduation: "Shortly, we shall receive our diplomas. These are our passports into the roads of life. The various paths which we have chosen. No one knows better than we

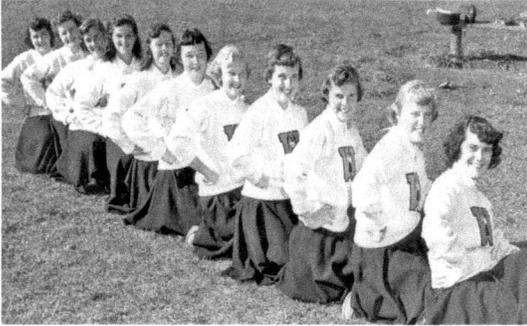

The 1953–54 cheerleading squad posing before the game. From front to back are Jeanne Flaherty, Martha Swanson, Julie Johnson, Janet Murray, Carole Hedblom, Joanne Hull, Jeanne Matson, Edna Sarno, Edwina Donohoe, Jeanne Canty and Joan Flaherty. *Photograph by the Farino Studio, courtesy of Janet Murray Bruno.*

as individuals how much we have attained or how much we have missed." Shirley Anderson Lundin, class of 1957, noted,

My happiest memory of my three years at Woburn High is being a majorette, marching and performing with the Woburn High band. The bus rides to the games, performing at half time (rain or shine) and the after parties at someone's home.

We would practice marching with the band every afternoon and then go to the Spa to have refreshments and some music from the jukebox. Woburn High School was (and still is) a great place and I consider myself lucky to have been a part of Tanner Pride!

George William Harvey, class of 1954, has always had a sentimental tie to the school:

I joined the Naval Reserves in February, 1954, at seventeen years of age, knowing that I was going to be drafted as soon as I was graduated from high school in June of that year. On my last day of school, I was very sad knowing I would never be a student here again. I walked through the school from the fourth floor down to the first by myself viewing all my classrooms and remembering all the great times we had. I just loved school so much because I was involved in many activities and had many great friends. Life at Woburn High was great! I still see all of my friends now, it is very important that we all stuck together.

Janet Murray Bruno, Class of 1954, recalled:

My years at Woburn High School were the best years of my life for fun, friendships, and a great education that allowed many of us to attend college.

I belonged to many activities and especially enjoyed being a cheerleader. Many friendships were formed in grammar school and carried through to high school. It makes one realize that the old saying 'Make new friends but keep the old, one is silver and the other is gold,' is really worth believing. How delightful it is to have known someone since you were five years old who knows you for who you are because of your school days. It is remarkable today when I tell strangers how we have retained our high school friendships for over sixty years. For us diehards, WHS will always be home.

ATHLETICS

Athletics have become an intricate part of a student's life, and many community establishments join in to support school spirit. The popular Town Line restaurant in South End hosted many annual athletic association luncheons, and the John J. Riley Tannery donated banners made from two hides tanned and finished. One hide was in black and the other orange, maintaining the Woburn tradition as a tannery town.

Notable games included the 1951 baseball team capturing the Northeastern Conference Championship after a twenty-three-year drought from the last championship. The 1953–54 basketball team won the Northeastern Conference Championship title and ended with a 15-5 record. For several years, the games to watch were the Thanksgiving Day games, with Woburn's Joe Castiglione and Winchester's Joe Bellino battling it out every year. Castiglione was later drafted by the Red Sox, and Bellino went on to win the Heisman Trophy. The 1954 football team went undefeated and won the State Class C Eastern Mass Football Championship title with a win over Winchester in front of eleven thousand fans. The team went to Washington, D.C., where it met Vice President Richard Nixon. John Danehy, class of 1955, stated, "Tanner Pride was all about beating Winchester at Thanksgiving in football." Peter Carbone, president of the class of 1959, loved being the quarterback for the football team. "It was a great honor to represent your school and city. A lot of the players I still see. There were long-term relationships that were developed by being on the team. We played on Saturday mornings and drew big crowds. I can still do the rundowns on the games now."

The hockey team re-formed after a twenty-four-year absence. Joseph Upton, class of 1956, was extremely grateful, as hockey planted the seed for him to go to college at the University of New Hampshire. Joe explained, "Hockey started in our junior year, and we had a lot of good

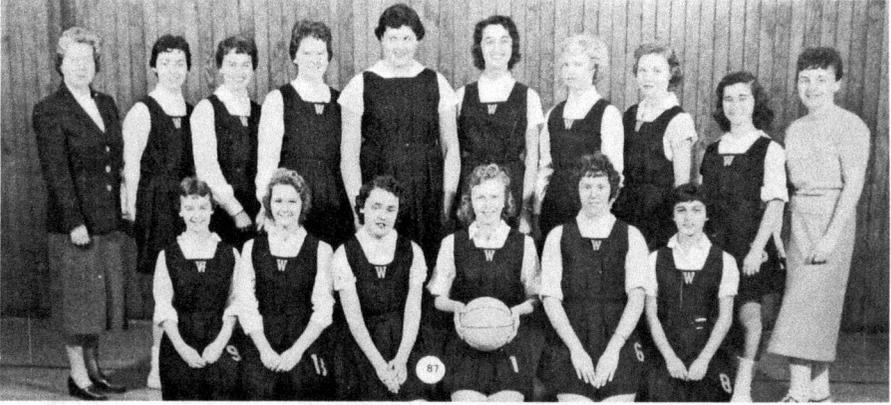

The 1958 girls' basketball team. From left to right are (first row) J. Davis, J. Johnson, J. MacDonald, M. Garvey, C. Moore and A. Gangi; (back row) Miss Higgins, Z.S. Buono, P. Kendrick, K. Brady, D. Russo, L. Preston, J. Anderson, P. Champlin, A. Danca and M. Doherty. *Woburn Memorial High School archive collection.*

hockey players. Students went to the school committee to get the hockey program started again. We were scrimmaging other teams, but we were not in a formal league. The biggest problem was lack of ice time. In 1955, we got into the North Shore League, and we won the Northeast Conference." The hockey program progressed favorably, and by 1958 the team had the only unbeaten regular season in the school history and won the coveted Woodman Cup. John Day, class of 1958, was captain of the team and recalled being the being the smallest player in the league at five feet, five inches and only 120 pounds.

The importance of being on a team was mentioned by several alumni, including Lawrence O'Connor, class of 1950, who "loved being captain of the cross country team" and recalled, "Our favorite hangout was on the cross-country course." John Dineen, class of 1955, said, "Track and cross-country was the reason I stayed in school. They were a great bunch of guys, who always gave their best." The cross-country team went undefeated in all its meets and captured the 1954 Northeastern Conference Track Championship and the 1957 Puritan Division title. The girls' program expanded with badminton, archery, softball and basketball. Only the field hockey team competed in league games. Paula Kendrick Fabello, class of 1959, said, "As for sports, I played basketball when girls could only play half-court back. I was also a cheerleader, and since most girls wanted to be in cheerleading, I felt very grateful to have

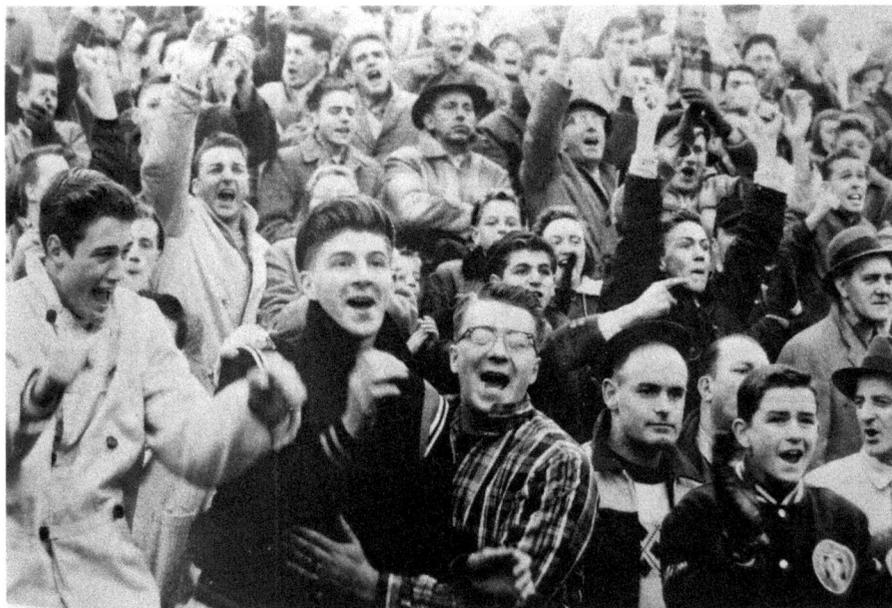

Victories and defeats . . . the thunderous applause from Woburn's enthusiastic crowds. *Woburn Memorial High School archive collection.*

been selected. I developed many friendships during my years at WHS and have always felt a strong connection to Woburn High School, largely because it represented a very happy time in my life."

The stands on a Saturday afternoon football game would be filled with hundreds of fans, and when Woburn scored a touchdown, the band played the fight song to the tune of "On Wisconsin." Over the years, there have been different renditions, but most would remember these words:

Black and Orange,
Black and Orange,
Show them how to fight
Keep the football under cover
Keep it out of sight
Rah, Rah, Rah
Black and Orange,
Black and Orange,
Give a hearty yell
Fight, fight with all your might
For Woburn High.

FUN FACTS

- The 1960 Betty Crocker Homemaker of Tomorrow winner was Marilyn Yundt.
- The band serenaded Elsie the cow from the Borden ice cream plant.
- In 1959, the starting salary for teachers with bachelor's degrees was $3,300.
- Students typed five hundred letters and mailed them out to help "lick polio."
- Girls dressed dolls that were donated to the Red Cross for distribution to needy children.
- *Tanner News* took third prize in the Columbia Scholastic Press Association ceremony.
- The senior winter dance was renamed the Snow Ball, along with the crowning of the Snow Ball Queen.
- The science fair began in 1959 for students to display their science projects and experiments.

TRADITIONS

The Story behind Student Government Day

Student Government Day was created by Donald A. Deluca, a former school committee member, in 1953 as a way for students to learn firsthand knowledge of their city government. Every year since, students are given a list of essay topics that range from personal, national or global issues. The top student essays are chosen, and those students are matched with a city official. Students spend half a day at an introductory group meeting, followed by a full day shadowing their city official. There is a dinner reception with recognition given to the students at the conclusion of the program. This unique program is extremely successful due to the cooperation of the school department, community organizations and city officials.

12

1960–1969

An Era of Significant Changes

We as parents remember the joy we had, and we want that for our grandchildren.
It is the fabric of the people themselves that are the heart of the City of Woburn
and Woburn Memorial High School.
—Carol Zubel Carbone, class of 1960

This decade experienced the most significant changes in U.S. history, as a nation went from being inspired by a young, charismatic president to feeling frustrated with the conflict in Vietnam. The feelings of peace, love and hope battled with those of anger, turmoil and crisis. Social and radical difficulties were expressed as students began to rebel against parents. Music became the soundtrack of their lives, and they listened to Motown, the Beatles, Bob Dylan and the Rolling Stones; traveled to a place in New York called Woodstock; and danced to the twist, mashed potato, hully gully, Watusi and the pony. The expressions "make love, not war"; "peace"; and "groovy, man" were part of the spoken language. The television became a centerpiece of the home as people gathered around to watch a man land on the moon and learn about the tragic deaths of John F. Kennedy, Martin Luther King Jr. and Robert F. Kennedy. Classmates wept openly when word came out that President Kennedy had died. Schools were cancelled for one day, and students ignored the ban on prayer. Students bowed their heads for the late president with opening exercises, including two minutes of silence and singing "God Bless America." Kathleen "Terry" Varey McCormick, class of 1965, recalled, "On November 22, 1963, we were in the old auditorium decorating for the Thanksgiving Booster dance. It was

a rally dance for the annual Woburn-Winchester football game to be held the next day. We skipped our last class and were midway through with the black and orange decorations when Principal Henry Blake came over the intercom announcing that President Kennedy had died. We were stunned. School was cancelled, and a lot of us students gathered together and walked down Montvale Avenue to St. Charles to pray. The game and the dance were cancelled. I know where I was the day Kennedy died: at Woburn High School!"

People protested against the war, as young students were drafted daily right out of high school. According to the 1960 archive book, "Three hundred or more Woburn students pledged to attend a monster pro-Vietnam rally on Wakefield Common. The students were on hand to support President Johnson's stand on Vietnam. The students proudly wore draft cards in support of the hundreds of thousands of American men in Vietnam." The class of 1969 gifted a memorial stone on Woburn Common for the eleven classmates killed in action. The magnitude of violence continued in the country with race riots on college campuses and in cities.

According to the book *Woburn, A Past Observed*, by John D. McElhiney, the housing boom continued but leveled off during the 1960s, and the apartment boom began and pushed the population to 31,241. In 1960, the Route 93 section was opened, but the city lost the Boston & Maine Railroad from Woburn to Lowell a few years later. Woburn's 325th anniversary was celebrated in 1965, and a new ski lift and ski area opened on Horn Pond Mountain in 1969.

FACULTY AND STUDENTS

Principal Blake reacted to the expressive fashion statements with a two-page dress code guideline. Blake stated that students must be neat, clean, well groomed and appropriately dressed individuals because it was a matter of personal pride. Boys were encouraged but not required to wear suits or jackets with ties. All shirts must be tucked in and have a collar. T-shirts, Levis or dungarees of any color were not allowed. Neatly pressed trousers or slacks, including chinos, could be worn with belts. Engineer boots or eccentric foot attire was not acceptable. Girls must dress in good taste, with conservative skirt lengths and no tightness of shirts or sweaters. Slacks, shorts or culottes were not permitted. Extreme hair, dress or makeup was not acceptable. Ellen Marie Winson, a former teacher, remembered, "There

was a dress code for students. If we suspected a girl's skirt was too short, we were supposed to send her to the dean of girls. The suspected violator was then asked to kneel on a straight chair, and her skirt hem had to touch the seat of the chair. If the hem didn't touch, a parent was called or she was sent home to change her skirt."

The senior high students attended school during normal hours, but a two-platoon system returned to the junior high students in 1962 due to the lack of space to accommodate the heavily increased enrollment. Half the students attended school in the first session from 7:30 a.m. to 11:45 a.m. and the second session from 12:15 p.m. to 5.00 p.m. Halfway through the year, the schedule would flip. For the first time in over thirty years, the senior high school would include pupils of the ninth grade. Due to the lack of space, the system had become a four-grade system out of necessity. By the time the new buildings were opened in 1965, modern IBM data-processing and record-keeping machines kept attendance, grades and the school register and plotted courses. According to the 1965 archive book, Principal Blake recommended that a housemaster plan be put into effect. Each housemaster would meet his or her class in ninth grade and follow them through twelfth grade. The school committee approved the plan in 1968 with the appointment of new housemasters James Brennan and Lawrence Gilgun.

Students were excited about the new buildings, but many felt that the old auditorium was a special place. Skylight Studios provided a description:

The old auditorium was a harmonious marriage of the antique and the modern for that time period. It was common for schools of that time to acquire or receive gifts of casts from the Caproni Collection in Boston to foster an understanding and appreciation of the classics. The auditorium held this respect for classical antiquity but also a contemporary vibrancy. Above the stage, the procession of figures in the Greek Parthenon frieze stands out in silhouette by an unusual application of blue in the background, as if they are performing a play for the audience. Flanking the stage and looking down at the audience are the Greek Pallas Athena and Roman Augustus Caesar whose sweeping forms are framed in blue by their respective geometric niches. All the elements are capped by a ceiling featuring a skylight encircled by abstracted Art Deco rays.

Elaine Graham Farmer, class of 1969 and former Woburn High teacher, loved the older buildings, especially the auditorium: "In the old auditorium the sunlight entered through the glass ornate ceiling in the center of the

The two-story glass wing of the brand-new addition. *Woburn Memorial High School archive collection.*

room with the lights that hang down around it, the balcony, craftsmanship of woodwork details, old wooden chairs bolted to floor, you were enchanted each time you entered. There was beautiful old architecture that had such charm." Paulette Addario Brogna, class of 1965, said, "I remember the fourth floor of the old building then after the renovations, the long walk to the gym from one building to another." Dick Cameron, class of 1964, recalled, "We had a new building the last year but the old building was quirky

and therefore fun." John Donovan, class of 1970, Woburn High teacher and foreign language department chairperson, shared this unique moment:

One of the most sentimental stories I have is the following. I was the organist at Saint Barbara's for two of my former students. When I met with them to discuss music, they told me they had fallen in love when I made them work together on a project. Their love had lasted throughout high school and college, and before the old school was torn down, the young man returned to my old room and proposed to his girlfriend on the spot where they had first met. I was so touched by the uniqueness of this story that I told them to put it into their printed marriage program.

Students felt that the heart of any school was its faculty, and their success depended in large measure on the caliber of their teachers. Phyllis Champlin Tapley, class of 1964, mentioned that she was working at an air force base that was closing, and everyone was losing their jobs. The state came in and administered a group of tests to find the employees' strengths and weaknesses. The administrators asked her where she went to school. "I answered Woburn High School. He said that he had a master's degree and I scored higher in the tests than he did! Thank you to all my teachers at Woburn High." Albert Boudreau, class of 1960, mentioned the dedication of teachers: "My recall stands extremely clear concerning the dedication of our teachers: men and women who cared for us and believed in our future."

Woburn High was just a special place to be, as several alumni explained: Jean Mary Balesteri Pulley, class of 1963, reminisced, "When I walked out the door of Woburn High, I would often walk across the street and see my father working at Murray Leather. So Dad was a 'Tanner' in the real sense of the word because he was part of the group working to tan hides. So 'Tanner' meant more to me than just the school, it was part of what Dad did, and that made the mascot special for me." Christopher "Pugsy" James DeSalvo Jr., class of 1960, noted, "The city has always been a city of working-class people. No pretentions, just hardworking folks just trying to do their share in life, raise their families, have fun and enjoy their lives. Sports was a central and integral part of our lives and has been the cornerstone for lifelong friendships." Judy Brophy Donaghey, class of 1960, felt the same way: "I think people in Woburn tend to stay connected with each other, especially if your high school years were enjoyable. Because so many of us stay here for our whole lives, we tend to know the teachers and coaches or the families they come from and can connect them with some good memory

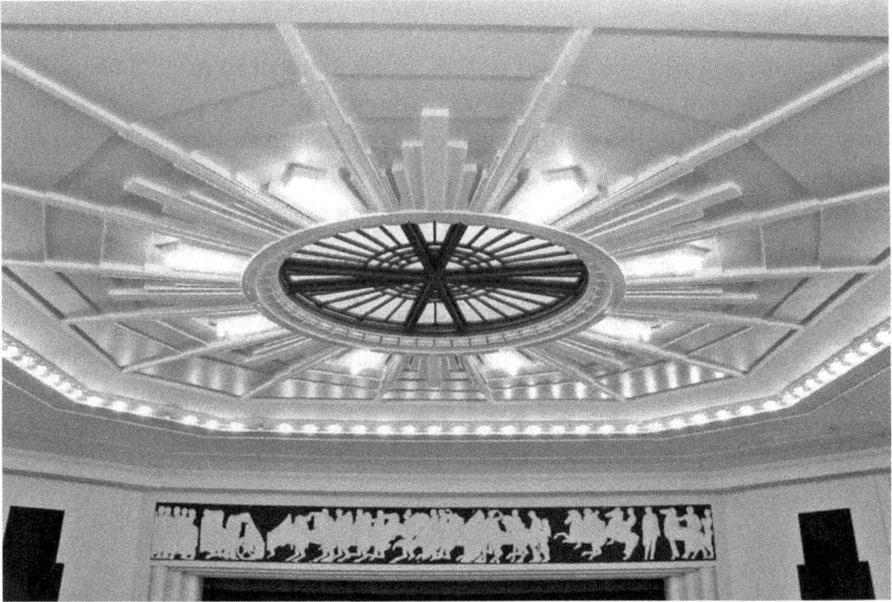

The old auditorium ceiling featuring a skylight encircled by abstracted art deco rays. *Author's collection.*

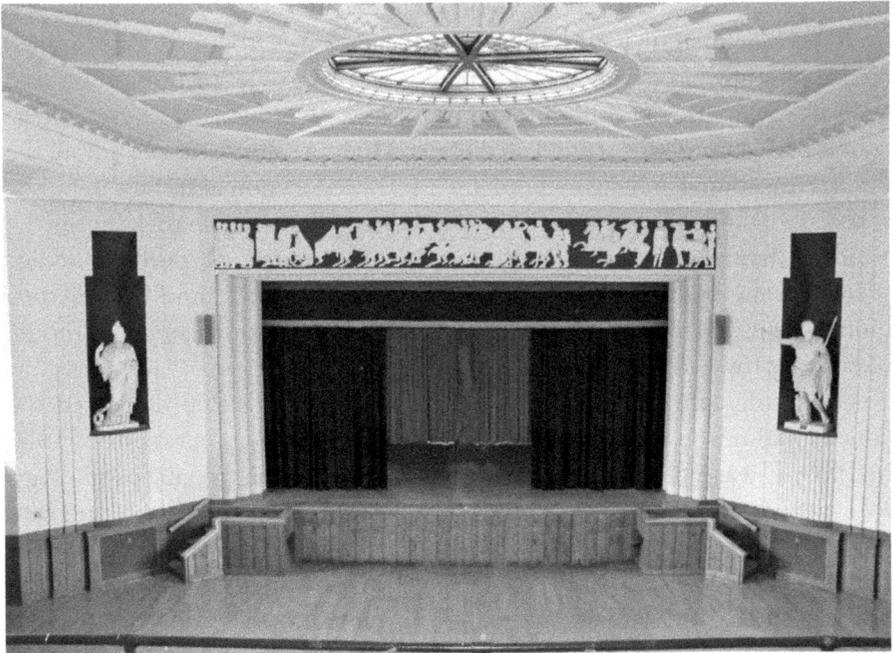

The 1929–30 auditorium was a harmonious marriage of antique and modern for that time period. *Author's collection.*

along the way." Alician "Lissy" Quinlan, one of three valedictorians, class of 1964, explained why the school system was important to her: "This system created a lifelong bond among Woburn kids that is very evident nearly a half century later in the communications sent to and from you. It's not just our classmates; it's kids of our era. We all have the deep sense of community created by our elders. Woburn is home to me because it's where I don't have to explain or defend my core values." Veronica McGowan Andrews, class of 1961, expressed, "It's a common place, a grounding, it's where we all set our roots, our basic beliefs were tested in high school and we learned to form our own opinions and set out on the highway of life." Stephen Hatfield, class of 1964, suggested, "It could be the upbringing that we had back in the '50s and '60s where you had all of those friends that you went to school with for twelve years and all afterschool activities along with those on the weekends and summer with the same folks."

ACADEMICS

Brendan Doherty, class of 1965, Woburn High teacher and history department chairperson, spoke about the curriculum: "The curriculum was pretty well defined; if you were in the college course, you took a prescribed course of study, no deviations. There also was course levels in business and general." Margaret D. Lundin, class of 1962, recounted, "I chose college courses. My knowledge gained at Woburn High prepared me well for all the future educational endeavors I pursued. It was education at its best in public schools. I couldn't have asked for any better education than I received." Sandra Champlain MacPherson, class of 1960, stated, "I loved my senior year, with my business course. It was my favorite subject and I learned so much. It helped me so much in my employment and keeping in-home records for my checking account."

The curriculum was revised to reflect new methods that enhanced the educational needs of the students. In the annual school reports from 1960 to 1969, it was noted that new subjects of automobile repair, psychology, sociology, anthropology, German, Russian and an updated health program were introduced to reinforce these needs. The business education department added a course in secretarial skills for girls who wished to achieve the top office positions. In 1965, a modern electronic data-processing department was instituted while in 1966 a distributive education program was developed. The first advanced placement class was started in English, and by the end

The most popular courses in the business department were the typing classes. *Woburn Memorial High School archive collection.*

of the decade, chemistry, biology and American history had been added. In 1966, girls asked the administration if they could take courses in the new expanded industrial arts programs since boys were allowed to be in the great chefs course. They wanted to learn the basis of woodworking, printing and sheet metal, but the authorities refused. In 1968, enrollment reached over 2,500 students, including 50 students from St. Charles on a shared-time program in science. Kathy Kelly Lucero, St. Charles class of 1968, said, "We were lucky as freshmen at St. Charles that we were able to take biology at the high school. We rolled down our knee socks and put a sweatshirt over our uniforms. We had a wonderful experience that allowed us to meet other students and feel part of Woburn High."

ACTIVITIES

Rodney Flynn, class of 1964, knows what it means to be involved, and today he keeps all the high school memories alive by maintaining several alumni e-mail lists. "I have many memories of Woburn High School, especially the people I've met. First of all, I married my high school sweetheart and classmate, Sharon Audette." He remembered how much fun he had participating in track, Black and Orange Revue rehearsals, bus trips and parties. Rodney also stated, "Thank you to Woburn High for all the lessons, the friends and the involvement. They are more than memories; I have carried them with me through my life." Terry Varney McCormick, class of 1965, recalled the fun of the senior prom: "The senior prom had a theme and was held in May in the 'new' cafeteria with our color scheme of mint green and ice blue. The prom went from eight to eleven and consisted of a grand march, receiving line, refreshments of cake and punch along with dancing to Jack Flaherty's band."

According to the school archive book, in 1968, Woburn was one of the first ten communities in the nation to have a Naval Junior ROTC department. The program was established by the secretary of the navy in accordance with an act of Congress to preside over a select group of high school–aged young men. Lois Sullivan Surette, class of 1968, remembers her boyfriend and future husband, Gerry Surette, all decked out in his ROTC uniform.

Baby Day was a ritual held in the spring for seniors to reflect on their childhood memories. Students planned outfit ideas together, went to the fabric store, brought out the sewing machine and created baby outfits to wear to school. The first mother-daughter banquet began in 1963 and gave daughters an opportunity to thank their mothers and invite them for an evening out at the high school for a dinner, fashion show and music. In 1965, a record-breaking 850 happy, smiling mothers and daughters gathered in the new café for the annual mother-daughter banquet sponsored by the student council.

Alumni continued to express fond thoughts of school. Henry "Hank" Valentine, class of 1966, remembered, "Most of all I remember the feelings on graduation day realizing that we would be entering a world where we would now have to face a world on our own without the help of our teachers and the pride of knowing we now had the knowledge to succeed because of them and also realizing that we were now on our own. To this day, I think about those days." Robert Hasselbaum, class of 1965, added, "I remember the graduation ceremony on the old football field. Four hundred plus of us excited but a little apprehensive of the future. It was the time of the

The dance committee enjoying a dance. From left to right are Joe Iannacchino, Beth Mahoney, Doug Brown, Debbie Fenton, Tom Lynch, Terry Varey, Brendon Doherty, Donna Balboni, Tony Ciampo and Cynthia Carrns. *Woburn Memorial High School archive collection.*

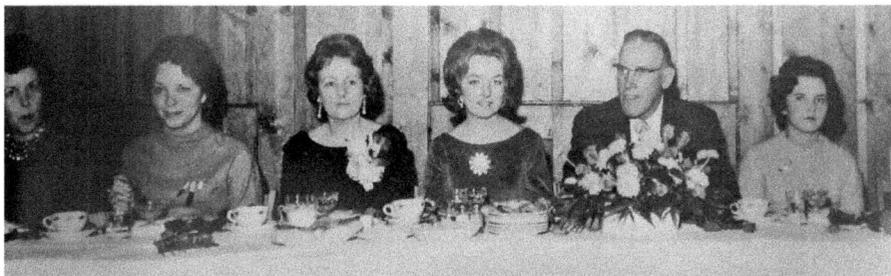

Top: The 1963 mother-daughter banquet head table. From left to right are Mrs. Stasiak, Susan Stasiak, Mrs. Eleanor Murray, Marjorie Murray, Principal Henry Blake, Ellin Flaherty and Mrs. Margaret Flaherty. *Bottom*: Record-breaking sell-out mother-daughter banquet crowd of 850 guests. Both, *Woburn Memorial High School archive collection.*

Vietnam War. For me, looking back, high school was a wonderful experience. My thoughts to future Woburn High School students would be to engage in all that is offered—the education and extracurricular activities. Appreciate the moment. Work to make it a wonderful experience. It is over so quickly, but the memories are for the rest of your life." Thomas "Tucker" Quinn, class of 1962, recounted, "The spirit of the school was school because it was the main focus. There were no malls, no cellphones. The corridors in the school were the meeting places for friends that stayed friends for life. Our class had a unique bond as I'm still friends with many of them because those friendships we made lasted forever. The classes were a family atmosphere, and each class could hang with each other." Carol Zubel Carbone, class of 1960, said, "It still comes down to the friends you make. The respect you have for each other. The involvement in the class and sports, all the proms, dances and decorating gave you a bond with those people. People have moved away, but you would be surprised with how many came back." Kathy Kelly Lucero summed up the high school experience: "High school is the foundation of their youth. I think you are so impressionable between the ages of fourteen and seventeen years that you are like a sponge and you absorb the good and bad in the heart of your soul whether you were dumped by a boy, lost the football game or don't have any idea what to do with your life. But all of those personal experiences always bonded to where you went to high school."

ATHLETICS

It was an honor to be part of a Tanner athletic team, playing your heart out for the black and orange. Students on athletic teams have the opportunity to broaden their horizons beyond the classroom and gain valuable experiences with sportsmanship, teamwork, loyalty and friendships. They learn the benefits of cooperation and the ability to work together for their school and community. Many excel outside the classroom and gain confidence, self-esteem and accountability in one of the many sports offered.

The year 1961 seemed to be a banner season, as Northeast Conference championships were won in baseball, basketball, football and hockey. The 1961 football team was considered one of the best in the school's history. The hockey program in 1963 went to round one of the state tourney and in 1964 reached the finals of the Woodman Cup playoffs. The 1968 baseball team won the Class B championship, and in 1969–70 the football, hockey and basketball teams switched to the Middlesex League division. Lois

Sullivan Surette, class of 1968, was captain of the girls' basketball team in her senior year and recalls practicing in a separate gym from the boys. Judy Brophy Donaghey, class of 1960, felt "sports were a big part of high school life, especially if you were a participant. There was practice every day after school, so you made friends with the same people who were with you every day at the gym. I remember making the girls' basketball team when it was a 'half court' game. In my sophomore year, I made the cheerleading squad, so I had to give up the other sports."

FUN FACTS

- Ted Kennedy visited the school as assistant district attorney.
- In 1960, the starting salary for teachers with bachelor's degrees was $4,400.
- The Leo Club was established in 1968 with the support of the Lions.
- Ellen Murphy was crowned Miss Teenage Boston.
- The Drama Guild won at the Mass Drama Festival.
- Girls joined the future nurses club: "Be someone special. Be a nurse."
- Sex education class became part of the overall health program.
- One-act plays were organized by and started in 1963.
- The class of 1969 had the first senior prom held outside school, at Montvale Plaza in Stoneham.
- Over 50 percent of graduates were continuing their education.
- The *Tanner News* newspaper changed its name to the *Sentorian*.
- The business education club promoted membership: "Every smart businessman knows his most important asset is a good secretary and they are hard to find."

TRADITIONS

The Story behind the Seven-Period Schedule

In a 1969 follow-up report from the Study of the Comprehensive High School in Massachusetts, the school made a change and moved away from the six-period schedule to a seven-period schedule in which each class was forty-three minutes in length. Students would have a homeroom, periods one, two, three, four, period five with three twenty-minute lunch

blocks, then periods six and seven. This new schedule would allow for growth of curriculum programs. Today, students are assigned homerooms and attend only for administration purposes when needed; otherwise, they report directly to their first-period class and continue the same seven-period schedule.

13

1970–1979

You Will Miss All of This Someday

A wise woman once said to me, "You will miss all of this someday."
Yes, Mother, you are right once again.
—*Mary Jeanne Tropea Wing, class of 1979*

The chaotic times of the 1960s spilled over into the 1970s, as this era saw cultural change, economic struggle and technological innovations. In the midst of all of the changes, the country welcomed its bicentennial, and teenagers celebrated the power of music with rock 'n' roll and a new dance called disco. Unemployment and inflation were soaring as people waited in long gas lines due to an energy crisis. Kathy Kenney, class of 1974, stated, "I remember that I walked to high school one year when we had the 'energy crisis,' so the clocks did not change and we walked to school in the pitch dark in order to be there at seven forty in the morning." Vietnam was still on everyone's mind, as current teacher John Donovan, class of 1970, recalled: "Vietnam was definitely the biggest issue especially for young adults. None knew what to make of it as the war taught us to question authority. We once had a strike against the lunch room, and we all refused to eat their lunches and brown bagged it. There was also another day in which many students stayed home to protest the Vietnam War."

Social issues of women's liberation, nuclear activity, Vietnam and the environment were scattered on the front pages of newspapers. Teenagers went wild with color and geometric patterns in their fashion choices of bell bottoms, Levis, plaid pants and polyester shirts. Frye boots, mood rings, elevated heels and earth shoes were all the craze in high school corridors.

November 4, 1970, marked the first day girls could wear slacks to school since the school committee voted on the recent change. In a letter, Principal Blake quipped, "As long as they are neat, proper and clean then the mode of dress is acceptable." Over 130 girls complained that miniskirts were too cold for the winter months, and it was brought to the school committee for immediate action. Girls also had issues with their physical education fashion requirements. Kathy Kenney recalled, "Girls in physical education class wore these dreadful blue snap front 'bloomers.' We graduated from them to one-piece blue jersey rompers before I graduated. Of course, gym classes were single sex, and we had the 'girls' gym' and the 'boys' gym.' Boys could wear gym shorts and T-shirts." Prom fashion statements were bold, with Victorian, prairie or peasant styles for the girls, while boys wore colorful tuxedos with ruffled shirts.

Bell bottoms, long dresses, purses and plaid pants were the fashion statements of the 1970s. *Woburn Memorial High School archive collection.*

The urban revitalization during the 1960s caused a huge demand for products in the 1970s and changed the landscape of the city. The population explosion of neighborhoods and highways carried over to consumer goods as people purchased appliances at the new suburban shopping areas that began to pop up around the city. All of the development put a burden on the local mom-and-pop shops. Students still hung out at local places; Janice Hemsworth Strom, class of 1972, said students spent time at Bill and Bob's in the South End, the bowling alley and the Strand Theatre. According to *Woburn, A Past Observed* by John D. McElhiney, large grocery stores took over the little convenient stores, malls were built and the concept of one-stop shopping came about. Chain stores with the names of Purity, Star Market, Zayre and Sears Roebuck moved in. Meanwhile, from 1970 to 1973, the city began to experience a tremendous amount of arson, vandalism and gang-related incidents, and parents warned their children not to hang out in certain areas of the city. The storm of the century, known as the Blizzard of 1978, crippled the area with over twenty-seven inches of snow in two days with hurricane-force winds. Highways, stores and schools shut down for over a week while the city cleared the snow, and students delighted in the extra days off, which extended into the February vacation break.

Faculty and Students

In 1971, the Woburn Teachers Association was at a standstill in major labor negotiations with the Woburn School Committee. After an agreement was not reached, over 300 teachers decided to strike, crippling the entire school system. Several union members were arrested and put into jail until the contract was settled two days later. Just as the teachers' strike finished, over 100 students decided to strike and skip school in 1973, when they protested a limited form of open campus. By the end of the decade, students went on strike again during the 1977–78 school year in the form of protest over a new attendance policy. St. Charles High School closed in 1973, and many students continued their education at Woburn High. The number of students in the building swelled to over 2,100 for three grades, with the class of 1976 taking honors for the largest in the history of the high school with 735 graduates.

The school system administration team in the late 1970s consisted of Superintendent Paul J. Andrews; Assistant Superintendent Dr. Lawrence

Students on the open campus strike in the 1970s. *Woburn Memorial High School archive collection.*

Byron Jr., class of 1942,; and Principal Henry Blake. Due to enrollment numbers, the high school administration team was reorganized with one assistant principal, Paul Sweeney, class of 1946, and an expanded role of the three housemasters for each grade: Joseph Curran, Paul Murphy and James Foley, class of 1952. The dean of girls' position was kept primarily for discipline responsibilities.

ACADEMICS

Student schedules, which were originally done by hand, were now completed with computer assistance. The guidance department was in full swing, with students selecting various popular electives that included woodworking, graphic arts, automotive repair, home maintenance and metalworking. In 1976, home economics changed to environmental living, and boys were now given the opportunity to take this course and learn the basics of nutrition and food preparation. Following the trend of coeducation, the physical

education classes had boys' and girls' instruction at the same time. A new cooperative work-study program was open to seniors on a pilot basis to give students the opportunity to obtain an education and income at the same time. Kathy Kenney mentioned, "We did enjoy the benefits of open campus, and School and Society was a recent innovation in classes. I took a typing class on the old-fashioned typewriters, as there were no computers to speak of back then." Mary Jeanne Tropea Wing remembered some of her favorite classes: "I was in the business program and most of my classes were located there. I spent three years, five days a week, learning Craig Shorthand, typing, and any other office procedure you could think of. I learned all there was to know about office machines. No computer then; our best friend was the IBM electric!"

ACTIVITIES

The foreign-language department expanded its cultural exchange programs to France, Spain, Italy, the then Soviet Union and Germany. Students had a wonderful opportunity to enhance their knowledge outside the classroom by visiting these countries and experiencing their culture. The band was at an all-time high of over 140 members and continued to have strong performances in competitions. This did not go unnoticed, as Boston mayor Kevin White's office asked the band and tumblers to help promote a film at Quincy Market. The 1978 film *The Brink's Job* was based on Boston's famed $2.7 million Brink's robbery in 1950. Lisa Collins Landry, class of 1976, recalled, "I was a drama geek and loved being in musicals or any play every year of my education. I spent all my study halls there as well as being part of the choral programs. I loved being a part of the flag corps as well. Great times at the games and being the state champion football team in my senior year."

ATHLETICS

It all started in 1973, when a new football coach named Peter Sullivan came to the city at the age of thirty-four and coined the phrase "Tanner Pride." Sullivan stated in a *Woburn Daily Times* article, "Tanner Pride is more than

football. It is our community. Tanner Pride is listening to the Woburn Band under the direction of Mr. Charles Collins play the National Anthem in the pouring rain at the Winchester game when the foul weather canceled out the hosting band and the Woburn flag corps, tumblers doing their routines on the field in two and three inches of mud." Thousands of "Tanner Pride, get the feeling" bumper stickers were visible on cars and promoted community spirit. Two years later, the community "got that feeling" when the headline of the front page of the December 8, 1975 *Woburn Daily Times* read, "Welcome to Super Bowl City, Tanners win 20–7 over North Quincy." Over fifteen thousand fans cheered the Tanners on to victory at Boston College Alumni Stadium. The teams were given a police escort home and a victory parade. Janice Hemsworth Strom, class of 1974, declared, "Tanner Pride is always checking the Thanksgiving Day football score against Winchester even though you graduated over forty years ago." James J. Foley, former teacher and principal, wrote, "This sentiment was not limited to the athletic arena, but permeated the entire school in every area, athletic, academic, and social. The increased feelings of mutual respect and togetherness framed the climate now of 'we' not 'me.' Long live Tanner Pride!"

The girls' athletic program received a tremendous boost with Title IX, a higher education amendment that went into effect in 1972. It prohibited discrimination on the basis of sex in education programs and activities that receive federal financial assistance, including athletics and sports. All-Scholastic athlete Diane Marciano Ivester, class of 1976, Woburn High teacher and wellness department chairperson, believed Title IX played an intricate role in her life. "As a result, secondary-level public school education made the choice to shift from same sex to coeducational classes. I felt at the time this help me enhance my athletic ability because I wanted to prove myself. I now became more competitive and assertive and didn't hold back my athleticism. The teamwork and friendships I made during my years at WHS always gave me the confidence I needed to succeed in whatever I did." All-Scholastic athlete Barbara Freeman Locke, class of 1978 and Woburn High teacher, also recalled, "Now I could not only play, I could compete and compete we did. It was a generation of dominating teams in the late '70s at Woburn High with products of Title IX. This success only helped with the reassurance that girls' sports were here to stay. Summer leagues, etc., began and we would never look back. College scholarships were being awarded to those who excelled. As I look back on my experiences, I wouldn't change it one bit. Although we had to fight for equality in sport, I truly believe my teammates appreciated what we had as we knew what it was like not to have."

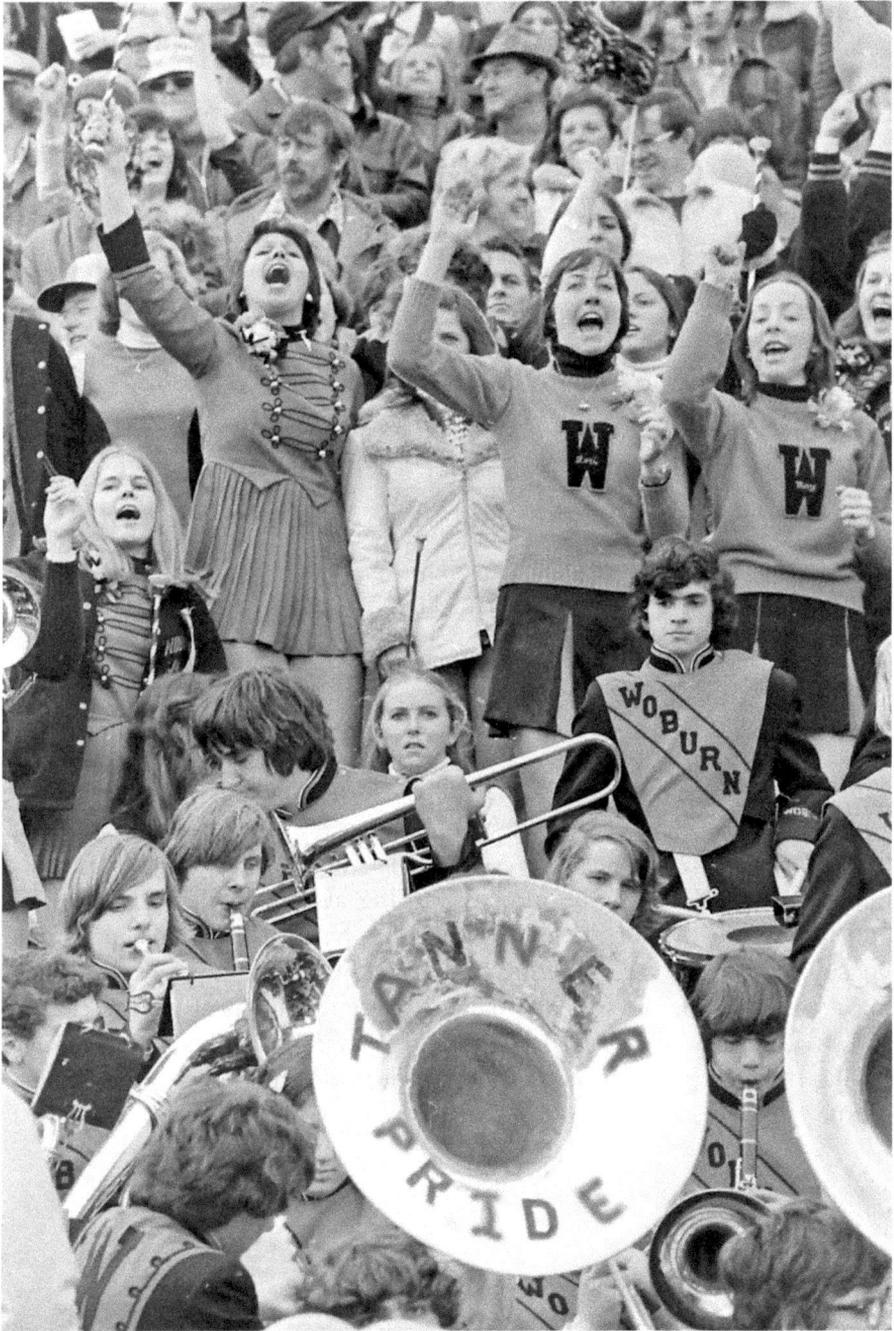

Crowds cheer at the 1975 Superbowl game at Boston College. *Photograph by Mark Haggerty, courtesy of the* Woburn Daily Times.

Coach Peter Sullivan and players after winning the 1975 Superbowl. *Photograph by Mark Haggerty, courtesy of the* Woburn Daily Times.

The girls made believers of those who paved the way for Title IX when the 1978 field hockey team made school history—winning a state championship title. All-Scholastic athlete Kate Martin, class of 1979 and teacher, recalled that moment: "One of the most rewarding athletic achievements I have had in my life: winning the Massachusetts State Championship in field hockey my senior year in the fall of 1978. My athletic experiences in field hockey, basketball, and softball obviously were highlights of my high school career. Representing Woburn High School, wearing the black and orange, having our teams referred to as the 'Orange Crush,' and being called the Tannerettes were all reasons to be very proud."

Fun Facts

- Student council booster dances were held in the café with live rock 'n' roll bands.
- A radio was installed in the school cable station.
- The Navy Junior Reserves Office Training Corp (NJROTC) rifle team started in 1979.
- In 1972, the starting salary for teachers with bachelor's degrees was $8,021.
- Class election campaigning was a major event, with posters, buttons, decorated cars and even a campaign pony.

Traditions

The Story behind Open Campus

A 1971 letter from superintendent of schools Charles Lamontagne introduced a modified open campus program. This adopted plan provided opportunities for students to assume more responsibility for their educational growth and transition from high school to college, institutions of advanced training or the job market. The program permitted qualified eligible seniors with a first or last study period of the day to obtain options of alternative opportunities. The school committee voted to extend the program to juniors and sophomores. The open campus program concept has changed several times over the years, and today only seniors can elect to have this option either period one or period seven.

14

1980–1989

Advances in Technology

We have walked together in memories of friendship and happiness;
may they last forever.
—Susan B. Thifault

O pen any yearbook published in the mid-1980s and you will see girls with tons of big hair. "I want my MTV" influenced a generation as they watched expanded cable television with Nickelodeon, CNN, MTV and ESPN streaming twenty-four hours a day. Videocassette recorders were popular, but the product that changed the lifestyle of America was the personal computer. In 1982, *Time* magazine declared it was the year of the computer, and the industry was off and running with IBM, Apple Macintosh and Microsoft leading the way for people to have at their fingertips desktop publishing, accounting and personal finances. The economy was growing rapidly, and many middle-class folks invested in the stock market—leading to the creation of the term "yuppie." These young urban professionals wore polo shirts, sported Ray-Ban sunglasses and drove the most expensive status cars, and that style was reflected in school. The physical fitness boom had everyone working out to fitness videos, which in turn helped with the expansion of health gyms. Teenagers were influenced by movies and music more than ever. They discussed the movies *Footloose, Dirty Dancing* and *The Breakfast Club* in the hallways and listened to hip hop, soft rock, alternative and contemporary music on their Walkmans.

Generations of new students walked into school, and lifetime friendships were formed. Linda Landino Martin, class of 1980, reflected, "I am proud

to say that I am still the best of friends with my friends thirty-five years later, but what is more special is that I have been able to share my life with their children and watch them all grow up to be outstanding young adults. My friends have all done an amazing job as parents. I love them all." Maureen Walsh Sakakeeny, class of 1980, remembered, "I think the common roots brought everyone together, mostly Italian or Irish backgrounds, Woburn-born and bred, middle-class families. No wonder Bruce Springsteen and Bob Seger were popular—they were regular people with everyday struggles and problems." Julie Pender, class of 1980, also mentioned that her best memories were with her high school friends and her trip to Spain.

The last tannery, John J. Riley Tannery on Salem Street, closed its doors in 1985. The Woburn Public Library was designated a National Historic Landmark in 1987. Woburn celebrated one hundred years as a city and the 105th anniversary of Goodyear's discovery of the vulcanization of rubber. Citizens sadly said goodbye to Choate Memorial Hospital after eighty years of service to the community. An environmental issue linked the two words "Woburn" and "water" together forever, as chemicals that were leaked into the city's wells caused a cluster of childhood leukemia cancer cases in East Woburn neighborhoods. A court case against W.R. Grace and Beatrice Foods became known around the world when the book *A Civil Action* by Jonathan Harr became a Hollywood movie.

FACULTY AND STUDENTS

Principal Blake retired in 1980 after twenty-nine years as a dedicated educator and distinguished citizen of Woburn. Housemaster James Foley stated, "Henry had initially inherited a simple, well-defined community school and guided it through the complexities of expansion, turmoil, and the accelerated changes of the next thirty years." The school committee looked in-house and selected Foley as Blake's replacement. Foley was a student in Blake's first graduating class, a teacher, advisor, coach and administrator. The administration team under Foley consisted of Assistant Principal Paul Sweeney and housemasters Joseph Curran; Robert Deluca, class of 1962; and Paul Murphy. Around 1982, the administration team was reduced to two housemasters. In the later part of this decade, the new middle school concept had the ninth graders move to the high school, thus starting a four-year high school career.

In 1981, the buzzword was Proposition 2½ due to an increase of that percentage added to taxpayers' bills as a safeguard for the city. Unfortunately, it came with department layoffs, including the public school system. Many of the school's youngest teachers were let go, and it changed the tone of the school culture. According to the 1980 school archive book, 62 members from the school system were laid off, and several athletic teams were cut from the program. In protest to these budget cuts, over 1,300 students walked out of school and marched to city hall to support the school programs and staff. Later in this decade, students also expressed their opposition to the new disciplinary codes that were published in the school handbook: "There will be no public display of affection, wearing of hats, and smoking on school grounds will not be tolerated. High school is not a place for any kind of affection. Any kind of physical contact will be viewed as a public display of affection and be dealt with. Such displays are not in good taste and have no place in school." The students felt they had a right to express their opinions by taking a stand on school issues and standing up for what they believed in.

ACADEMICS

A computer advisory council was formulated to review the development of a system-wide computer curriculum. It was noted in a 1981 *Woburn Daily Times* article: "In the near future, Americans may be called functionally literate not because they cannot read or write, but because they cannot operate a computer, computer jobs will exist." The school system also established department head positions to supervise grades seven through twelve in all major subject areas. Assistant Superintendent Dr. Louise M. Nolan established the W3 (Woburn Expects Excellence in Education) Program for the school system, which raised the standards in all academic areas in the city. The entire school system adopted this program into their curriculums, and it was reflected in the course selections in the high school program of studies booklet. Students needed to complete four years of English, math, science, social studies and physical education along with two years of a foreign language, fine art, business and technical education in order to graduate. Paula Carney Ray, class of 1980, stated, "Typing was the most valuable course for me. I took business courses because I wanted to work and make money instead of going to college. I remember geography class. I thought it was interesting, and it inspired me to travel the world, so that was a nice gift."

Donna Peary Murphy, class of 1980, commented, "I took honors courses, I had homework but I find now students have more pressure to take advanced placement courses. We did not get homework, and we never had summer reading assignments or homework. Actually, when I think back, the most valuable class I had was typing in the business department." Joanie Upton Gorman, class of 1980, stated, "Academically, I think the biggest thing we worried about was the SAT test during junior year. Junior year was very important and we wereasked about colleges when we visited the guidance department. It was a difficult time, as we had to make decisions on what we wanted to do for the rest of our lives."

ACTIVITIES

The school community was blessed with an abundance of service clubs and organizations that gave many students the opportunity to volunteer and experience a different aspect of school. Many students gravitated toward the band program with the flag corps, tumblers, majorettes and cheerleaders. Carolyn Young Rosa, class of 1980, enthused, "I loved being on flag corps, it was unbelievable. We carried the banner out to introduce the band and then performed with our black and orange plaid skirts, long black lettermen sweaters. It was an honor to be part of that group." Maureen Walsh Sakakeeny mentioned, "I remember being on the tumbling team and performing, making pyramids at the muddy fifty yard line on the home football field. We had breakfast in the café before the football games and walking to Woburn House of Pizza downtown for Saturday lunch after practice."

ATHLETICS

There were many banner years in the 1980s athletic programs with the 1980 boys' basketball and football team winning the Middlesex League Championships. Athletes were constantly breaking school records in hockey, golf and track. The girls' athletic teams established themselves as a dominant force with Middlesex League titles in basketball and cross-country, and they began to make history with individuals breaking scoring records in basketball, outdoor track and field and cross-country. A boys' lacrosse program was

started, as Robert F. Prokop Jr., Class of 1980, explained: "Lacrosse was in its infancy when I started playing. The city of Woburn did not have a feeder program so this put us at a huge disadvantage with the other high schools we faced. Needless to say, we weren't very good. We ended up winning only one game in three years. That one win felt to us like we had won the Super Bowl!" The 1988 girls' cross-country team coached by Bill O'Connor, class of 1961, won an unprecedented amount of championships, including Division One Eastern Massachusetts championship, Northern Area championship, Middlesex League championship, Boston All-Scholastic Team, Catholic Memorial Invitational championships and Our Lady of Providence Invitational championship.

FUN FACTS

- In 1980, the starting salary for teachers with bachelor's degrees was $14,019.
- An alternative education program started in 1986.
- The class of 1987 had three valedictorians.
- A battle of the bands with a lip-syncing contest was held with the annual Dinner Theater.
- Art students were awarded gold and silver keys at the Boston Globe All-Scholastic Art Show.
- The class of 1987 graduated in ninety-five-degree heat.
- Athletes visited Winchester Hospital caroling over the holidays.
- Boston Celtic Ernie DiGregorio visited the school.

TRADITIONS

The Story behind Evening of Fine Arts

In 1984, art department chair Frank Newark established the Evening of Fine Arts along with Assistant Principal Paul Sweeney, English chair John Flaherty and choral director Robert Hodgson. The evening highlighted a public-speaking contest, artwork and a choral performance. Over the years, the event has evolved from an all-school kindergarten through twelfth grade program to a weeklong event renamed Celebration of the Arts with an art exhibit and musical performances from the band and chorus.

1990–1999

Preparing for Future Educational Needs

Tanner Pride extends far beyond the athletic fields or courts. It is something that once you live here, you can't wash it off of you. It starts with cheering for the home team but truly lives in the relationships formed throughout our school years. To me, that's what Tanner Pride is: rallying around fellow Tanners in good times or bad, no matter the time or distance.
—Abby Severance Gillis, class of 1998

Technology advances started to become part of everyday life, and media as we knew it changed along with how it was distributed. The Internet, blogging and instant messaging were new vocabulary words, and families learned how to dial up on American Online (AOL) and wait to be connected to the World Wide Web. They listened to the words "You've got mail" when they checked their e-mail for messages. Global positioning system (GPS) started to replace maps, and students started to "google" information on their computers. A district-wide school technology plan was developed, and according to the school newspaper, the *Tanner Banner*, the school's one connection to the Internet was upgraded and would have its own network with monorail computers to be placed in the learning center and library. Social media sites begin to appear in the late twentieth century, leading people to upload photographs and create personal profiles. As technology was becoming appealing and accessible, a new book series was released, and the world became obsessed with a boy named Harry Potter as all generations shared in a common read that made reading books cool again. Teenagers became obsessed with reality television, which was reflected in their fashion trends of grunge, casual chic, baggy pants, hoodies, body piercings and tattoos.

The unique ties to the community and Tanner Pride remained strong, as Woburn High teacher and alumnus Stephen Sullivan, class of 1992, expressed, "This term took on even greater meaning as I grew up and realized that 'Tanner Pride' means far more than just supporting your local high school athletic teams. It means coming together when anyone in the city needs help or assistance, volunteering your time to help mentor and coach the youth of the city and giving back to the city that helped make you who you are today. There is a reason many people have deep roots in the city of Woburn and care so much about this great city, and I am proud to say that I still carry that strong feeling of 'Tanner Pride' with me to this day!"

FACULTY AND STUDENTS

Principal James J. Foley retired in 1993, one of the few to witness the history of the school as a student, teacher, housemaster and principal. Foley's personal vision for the school led him to develop new policies and programs that enhanced the school environment. Superintendent Dr. Carl Batchelder welcomed Robert C. Norton as school principal. Norton was a Rutgers University graduate, former principal of two New Hampshire schools and hockey commentator for New England Sports Network. Norton's administration team consisted of two assistant principals, Paul Sweeney and Leona Shanholtz, class of 1964, who supervised an estimated 1,400 students from grades nine through twelve. Later, Brian Shaughnessy, class of 1971, would replace Sweeney. Brian recalled that when he returned in 1998, there were still quite a few faculty members remaining from his high school days: "I will always be appreciative of the way they made me feel welcomed as the new assistant principal." Many former students continued to be hired, as the percentage of alumni teaching at the school was at an all-time high of 80 percent.

ACADEMICS

In 1998, the new Massachusetts Comprehensive Assessment System (MCAS) exam was mandated by the Department of Education as an assessment tool for all schools in the state. Students in grades four, eight

and ten were given exams in math, English, science and history. The levels of instruction listed in the program of studies were advanced placement courses for students to had the opportunity to study in a college-level course. Honors-level courses were offered for students who had a high level of proficiency in a subject. Academic courses were the preferred level for post–secondary school. Enhanced competence courses were for students who tested below grade level in certain subjects.

ACTIVITIES

The old auditorium continued to be the venue for one-act plays, class assemblies, art shows and music programs, as well as many community events. The unique character of this sixty-year-old hall was a perfect setting for the freshmen and sophomore semiformals and holiday dances. The ambiance of the skylight, balcony seating, hardwood floors, stage and art deco design simply added to the dances with its old-school charm. Activities committee members with ladders in hand spent part of the school day decorating the auditorium with theme-related posters, balloons and streamers for these dances. The junior and senior proms were always held at an outside venue, with the senior prom being the social highlight of the year. Seniors were excited as they bought beautiful gowns, rented tuxedos and hired limousines for one of the final events of their high school careers.

In 1998, Principal Norton became the first principal in Massachusetts to award diplomas to World War II veterans who left

Even in the 1990s, the old auditorium was still a beautiful place to hold a dance. *Woburn Memorial High School archive collection.*

high school to serve the country. Students, staff and family members were moved to tears as they stood and gave a standing ovation to these veterans in a moving Memorial Day ceremony called Operation Recognition.

ATHLETICS

Woburn became an athletic powerhouse with many Middlesex League championships this decade, including girls' gymnastics, boys' soccer, indoor track, boys' hockey, swimming and a state championship for the boys' golf team. Many individual athletes continued to break records in basketball, track, football and hockey. Meghan Patrissi, class of 1992 and Woburn High assistant principal, recalled how girls' athletics had evolved: "I was a member of the Tannerettes varsity soccer team. In my freshmen year, we were given the old boys' polyester soccer uniforms and played on the back field. Before games and practice, we would do a 'rock walk' to remove the large dangerous rocks. By the time I graduated, we had new uniforms and played under the new lights in the all sports Connolly Stadium."

FUN FACTS

- The first all-night graduation party was held in 1991 at the Woburn Country Club.
- The temperature varied building to building from thirty to seventy degrees.
- There was a bomb shelter located under the new café.
- In 1995, the starting salary for teachers with bachelor's degrees was $25,795.
- The average expenditure per pupil in 1997 was $7,925.
- A lip-syncing contest in which students and staff performed to Top-40 songs started in 1997.

TRADITIONS

The Story behind Move Up Day

Move Up Day was started in 1999 as a way for the eighth graders to visit the high school to walk through their class schedules. On the day before the last day of school in June, all students attended their new classes, met teachers and received course information and assignments. Today, Move Up Day continues to be an added benefit for students and faculty anticipating the upcoming school year.

16

2000–2016

A New Century of Learning

Containing a brand-new slate, a new beginning, pure and white waiting,
anticipating the impressions that would be left by those who walked
through its halls. Unable to contain its unbridled joy at the prospect of new
individuals, to christen its hallways, its classrooms, its stairwells and benches
eager to begin a new life.
—*Christina Freitas, class of 2007*

Students at the beginning of this century were only on the cusp of technology that was beginning to shape this era. In a rapid-fire pace and a flip of a switch in the mid-2000s, technology suddenly made a tremendous impact on all of our lives. Instant messaging rapidly changed to sharing and posting to social media sites YouTube, Twitter, Instagram and Facebook. As earphones dangled around their faces, students listened to hundreds of pop, country, rap and independent songs on their iPods. By 2016, students had the world in their hands as they checked their iPhone or Android cellphones for messages, tweets and snapchats. Texting became the norm, and to some extent, it replaced conversations in the hallways, as students constantly checked their phones. Their lives as they knew them were always on instant mode. You could google information on the computer to check out the latest high school fashion trends of Ugg boots, North Face jackets, boat shoes and flip-flops or text your friends to see if they were hanging out at Breakers Ice Cream, Bickford's, Dunkin' Donuts or Horn Pond.

The country experienced the ringing in of the New Year with a new century, the drama of Y2K, Hurricane Katrina and the worst financial

crisis in 2008 since the Great Depression. But our lives were altered forever with the attacks on American soil on September 11, 2001. At this time, students did not have access to cellphones, and many school rooms did not have televisions or computers. Many teachers were informed from outside phone calls from their families. Julie Paris, class of 2002, a descendent of Woburn's Edward Johnson, tearfully recalled how students were so sheltered and there were no protocols on how to handle a situation like this.

> *We just went on with our daily lives as if it was normal. Sports were cancelled, and everyone did a good job of protecting all of us, but I felt a little guilty because I was almost eighteen at the time and should have been more aware of how terrible the situation was. I think we should have known how to handle it or known exactly what is going on, but I guess we lived in a high school bubble. I spent the whole day in class and then the seniors got together and made red, white and blue pins, it was the right thing to do. It was just scary how we were impacted.*

The city of Woburn's population continued to grow to over thirty-nine thousand in 2013. The community once again stepped forward to support the building of new schools, including the high school and several elementary schools. The Woburn Public Library received approval for an expansion project, and in typical New England fashion, we experienced record high temperatures of seventy degrees in December 2015. Generations later, students still honored the fact that Woburn was still a special place to live. Jonathan Roketenetz, class of 2008, expressed his ties to Woburn. "I think Woburn has a strong sense of self and its own history just as most cities have pride especially in New England. But I always felt Woburn had a little something extra. Many city officials are Woburn graduates and current residents. A lot of city events and happenings are involved with the school, organized by school employees, or take place in or around the school. The school itself was one of the oldest in this area, and even though that 1906 building is gone the sense of history is still there."

FACULTY AND STUDENTS

Principal Bob Norton, along with Assistant Principals Maryanne L. Andrew and Brian Shaughnessy, became part of history as they worked together with

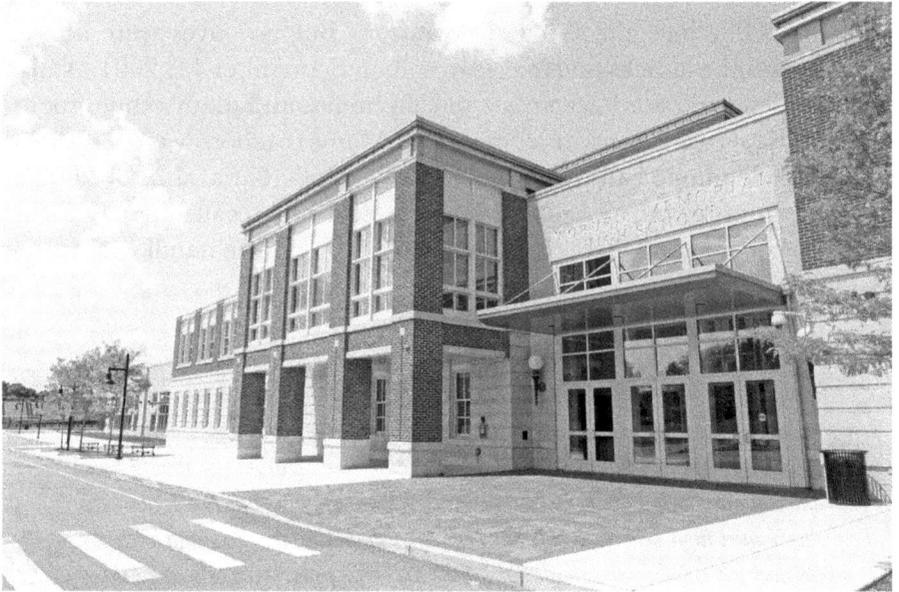

The 2006 building main entrance adorned with the 1906 building torch lights that have been passed on to another generation. *Photograph by the author.*

city and school officials to campaign for a new school, celebrate the victory, make the monstrous move and set up the school. The administration team had major changes over the next couple of years, with Andrew departing in 2008 and Norton and Shaughnessy in 2009. Norton retired after several tremendous undertakings that included the school being put on probation, passing the debt override, construction and demolition. Bob was technically an outsider on paper, but he will always be remembered as a principal who embraced the Woburn community as his home and had the students' best interests at heart. Some say Norton was a true Tanner. In 2009, Superintendent Batchelder named Reading Memorial High School principal Joseph Finigan as the new administrator. Finigan, a Tufts University graduate and Belmont native, stated in a *Daily Times* article that he was looking forward to the challenges that lay ahead. In 2014, a third assistant principal position was added due to the numerous responsibilities and amount of students in the school. The team consists of Edward Maguire, class of 1983; Ralph Deldon; and Meghan Patrissi, class of 1998. In 2015, Dr. Matthew Crowley was hired to fill the role of assistant superintendent after Dr. Gary Reese departed. In the early spring of 2015, Finigan announced his retirement.

Academics

According to the 2000 school archive book, the class of 2003 would be the first class required to pass the MCAS tests of English and math to meet school requirements in order to earn a diploma. Students learned to balance a busy lifestyle that consisted of homework, sports, clubs and volunteer work. If students plan to apply for college, they may be required to take both the SAT and ACT tests along with filling out the Common Application. Students pursuing a challenging curriculum were required to take four years of English, mathematics, science, social studies and physical educations; two years of a world language, the fine arts, business and health; and one year of family and consumer science. In 2006, the school webpage became a source of information for parents, students and faculty.

Activities

Norton established a Principal's Cabinet of seniors who advise the administration on student concerns. A bank branch added inside the school continues to operate in conjunction with the business department. The Woburn Public Media Center, a fully equipped studio, films all student activities, including the morning announcements. Students have the opportunity to participate in over forty clubs and activities. One of the many annual events held is the Interact club's annual dating and "mix it up day," when students have lunch with others by breaking down school social barriers and making new friends. In 2006, the yearbook staff paid an emotional tribute to the old school and the last class during the year-end ceremony. The class gave a standing ovation to the alumni members from every decade from 1930 to 2006 as they marched into the historic old auditorium to "Pomp and Circumstance" to say goodbye to the school.

Jeff DePaoli, class of 2000, wrote that several teachers had a positive impact on his life. DePaoli particularly enjoyed participating in the band, chorus and theater programs. Lindsay Connors, class of 2008, also recalled fond memories: "The mother-daughter banquet was one of my favorite traditions. It was such a special night to hang out with your mom or another inspiring woman in your life." She also commented on friendships: "My friends from Woburn are still my truest friends. I remember when I went off to college, some people found it odd that I was still so close to my high school friends throughout the years. My Woburn friends understand me in a different way than anyone else."

ATHLETICS

According to the *Bull's Eye*, girls' participation in high school sports has increased since the early 1970s, when only one in twenty-seven girls played sports—now one out of every three girls plays a sport. Women have made huge strides since Title IX, and they have proven to be strong competitors on the athletic fields. The expansion of the athletic programs now includes girls' hockey, lacrosse and volleyball teams, as well as a boys' lacrosse team. The athletic offerings are at an all-time high, with fall sports consisting of soccer, football, golf, cross-country, field hockey, swimming and volleyball. Winter sports include hockey, track, basketball, wrestling and gymnastics. Rounding out the year, spring sports include baseball, softball, track, lacrosse and tennis.

In a historic nod to athletics and the old school, the yearbook staff hired a helicopter to take an aerial photograph of the last Thanksgiving Day game at Connolly Stadium in 2005. The school and community showed their spirit by wearing black and orange as they bid a fond goodbye to the many memories that were made at that stadium.

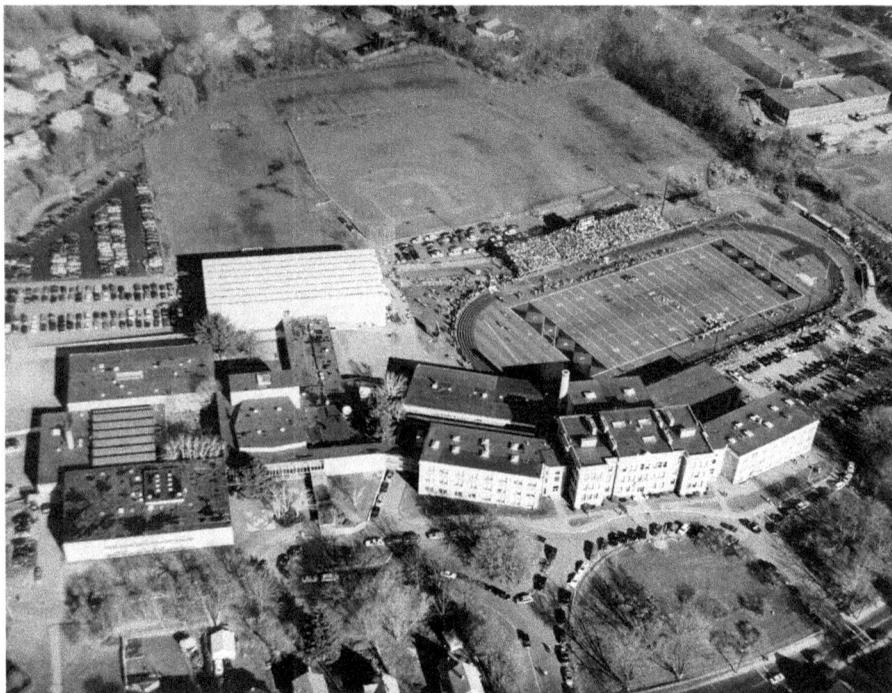

A helicopter was hired in 2005 to photograph the last Thanksgiving game played on the football field. *Photograph by Don Varney, On the Fly aerial photography.*

The Tanner Pride athletes continued to bring numerous accolades to the school, including state championships, Middlesex League titles, Division One North titles, All State and sectional titles in boys' soccer, wrestling, softball, gymnastics, field hockey, cross-country, indoor and outdoor track. Several highlights include the girls' hockey team making history as they captured state championship titles in 2003, 2004 and 2006. The golf team coached by Bob Doran continued to add two more state championship titles, along with an unprecedented number of Middlesex League and North Sectional titles. The 2005 football team won all twelve games and the Division One A Superbowl championship under coach Ronald Rocky Nelson, class of 1962. The 2008 boys' indoor track team earned two individual state titles, a team state title and a national championship in the 4-by-400. In the 2008–09 season, Woburn teams also made double appearances at the Boston Garden with playoff games in girls' hockey and boys' basketball. In 2016, the girls' basketball team made school history by winning the Middlesex League Liberty Division championship and the Division One North Sectional championship, earning them a trip to the Boston Garden.

FUN FACTS

- The 150th anniversary of Woburn High was celebrated in this decade.
- The senior class headed to an all-night party in Disneyworld for their class trip.
- A yearbook lip-dub one-take video received recognition from WCVB TV's sports director and anchor Mike Lynch.
- The *Tanner Banner* newspaper changed its name to the *Bull's Eye*.
- Ashley Walters, class of 2007, designed the school crest.
- "Welcome to the WU" became a popular saying.
- The average expenditure per pupil in 2005 was $11,825.
- In 2013, the starting salary for teachers with bachelor's degrees was $41,595.
- The first powder-puff flag football game was held at Library Field in 2006.
- By 2009, the name Tannerettes for girls' teams disappeared and all athletic teams were referred to as Tanners.

TRADITIONS

The Story behind Homecoming and the Promenade

The homecoming dance was established in 2007 as the first dance of the year open to the entire student body to promote school spirit. This sell-out event has an estimated four hundred students dancing the night away to the music of a disc jockey in the high school foyer. The junior class plans, decorates and announces homecoming king and queen.

Promenade was started by the class of 2012 as an opportunity for the family, staff and community members to gather in one location to view the seniors dressed in their prom attire. As seniors are announced into the gym, they take a red carpet promenade walk in front of the audience members. The promenade is a wonderful opportunity for the school and community to gather together to send off the seniors before their big night at the prom. Promptly after the event, relatives and friends are invited to take photographs at the school. Students then proceed to the prom, which has taken place at the Danversport Yacht Club for the past ten years.

There Is No Ending,
Just New Beginnings

*People gravitate to a sense of place and connection, and Woburn High has
been at the center of city history and tradition for generations. It's a big part of
"Woburn Pride."*
—Jonathan Roketenetz, class of 2008

This is the story of Woburn High, and unlike most stories, it does not have
an ending. This story has revealed that the underlining thread woven
into the history of the school has always been the people who have walked
through its doors. These people have valued the importance of education
and continue to be part of the school and community of Woburn. Woburn
is a unique city where outsiders are envious of the bond that has been passed
on through the years by alumni who continue to be dedicated to city and
school system. Alumni have enriched our schools and city over the past
160 years as superintendents, assistant superintendents, principals, assistant
principals, department chairs, teachers, paraprofessionals, custodians, café
workers, librarians, counselors, policemen, firemen, police chiefs, fire chiefs,
city council members, school committee members, mayors, city hall officials
and city department workers. This alumni bond will always be with us for
the rest of our lives.

Today, Woburn Memorial High School is where students learn lifelong
lessons and are part of both a school community and the community of
Woburn. Some students may form friendships that will last a lifetime and
others for just a moment, but they all share the same connection. When
graduation day arrives and they receive their diplomas, they will finally

Graduation day, where new opportunities begin. *Photograph by the author.*

realize that a new journey is beginning. This journey has created a bond with the thousands of alumni who have come before them. It is the symbolic gesture of smiling students tossing graduation caps into the sky that indicates they are saying goodbye to Woburn High and hello to the future. No matter how far they roam, Woburn Memorial High School and the city of Woburn will always be their home.

Those Who Came Before Us

Graduation Totals

Year	Total	Year	Total	Year	Total	Year	Total
1852		1893	25	1934	237	1975	691
1853		1894	43	1935	202	1976	735
1854		1895	28	1936	224	1977	725
1855	11	1896	56	1937	225	1978	640
1856	15	1897	55	1938	249	1979	715
1857	5	1898	44	1939	206	1980	657
1858	11	1899	55	1940	217	1981	607
1859	12	1900	54	1941	223	1982	572
1860	5	1901	55	1942	230	1983	535
1861	14	1902	44	1943	208	1984	492
1862	4	1903	62	1944	178	1985	500
1863	11	1904	54	1945	169	1986	451
1864	14	1905	54	1946	205	1987	377
1865	5	1906	62	1947	181	1988	426
1866	11	1907	20	1948	186	1989	343
1867	9	1908	52	1949	179	1990	341
1868	16	1909	41	1950	190	1991	305
1869	7	1910	50	1951	173	1992	275
1870	23	1911	64	1952	174	1993	291
1871	20	1912	65	1953	173	1994	278
1872	18	1913	67	1954	168	1995	285
1873	31	1914	54	1955	186	1996	246
1874	27	1915	56	1956	199	1997	268
1875	29	1916	69	1957	204	1998	254
1876	27	1917	88	1958	198	1999	254
1877	9	1918	88	1959	256	2000	241
1878	15	1919	97	1960	317	2001	290
1879	24	1920	71	1961	287	2002	281
1880	18	1921	83	1962	250	2003	299
1881	20	1922	77	1963	257	2004	309
1882	16	1923	88	1964	386	2005	330
1883	35	1924	93	1965	421	2006	270
1884	21	1925	99	1966	437	2007	323
1885	23	1926	102	1967	385	2008	333
1886	28	1927	148	1968	486	2009	297
1887	22	1928	138	1969	492	2010	319
1888	17	1929	125	1970	586	2011	324
1889	29	1930	130	1971	604	2012	275
1890	30	1931	151	1972	614	2013	302
1891	38	1932	161	1973	620	2014	294
1892	23	1933	173	1974	675	2015	317
						2016	340
							32298

Bibliography

Annual report of the City of Woburn, Woburn Memorial High School. Harlow Library and the Woburn Public Library, Woburn, MA. 1844–2015.

Annual report of the School Committee, Woburn Memorial High School. Harlow Library and the Woburn Public Library, Woburn, MA. 1844–2015.

Archive books, Woburn Memorial High School. Harlow Library, 1887–2015.

Basile, Leon Edmund. *A Union Town During the Civil War: Woburn, Massachusetts.* Vol. 1. Woburn, MA: Sonrel Press, 2012.

Bull's Eye. Woburn Memorial High School, Harlow Library. 1990–2015.

Cambell, William C., Robert E. Maguire, John D. McElhiney and Tom Smith. *Woburn Forgotten Tales and Untold Stories.* Woburn, MA: Sonrel Press, 2004.

Innitou yearbooks, Woburn Memorial High School, Harlow Library. 1947–2015.

McElhiney, John D. *Woburn, A Past Observed.* Woburn, MA: Sonrel Press, 1999.

Reflector. Woburn Memorial High School. Harlow Library. 1922–1944.

Rules and Regulations of the School Department. Woburn Memorial High School Library. 1912–1990.

School manuals, Woburn Memorial High School. Harlow Library. 1912–1974.

Woburn Daily Times, 1970–2015.

Woburn Journal, 1885, 1887.

Index

About the Author

One person can make a difference. I hope I did by writing this book.

Susan Thifault is a resident of Woburn and a 1980 graduate of Woburn High School. She continued her education at the University of Lowell and received a bachelor of fine arts degree and a master's degree in education from Rivier College. Susan has had several dream careers throughout her life: working as a professional studio photographer and videographer for Burlington Studios and as project manager for Maritz Communications Company working with Fortune 500 clients. Susan started teaching at Woburn Memorial High School in 1994, adding yearbook advisor and director of the fine art department to her title along the way. She has always had a love of history, especially genealogy, as she has traced her ancestors back to Woburn to the mid-1600s. Susan continues to volunteer in the community as a director on the board of the Woburn Historical Society and as a graphic designer for community programs.

About the Research Editor

Theresa Christerson has been a resident of Woburn since 1984. Before this, she lived in Winchester and graduated from Winchester High School. After graduating from the University of Massachusetts in Amherst in 1976, she worked for SEEM Collaborative in Reading. She continued her education at Regis College and earned a master's degree. In 1979, Theresa was employed by Woburn Public Schools as a special-education teacher and taught at Woburn Memorial High School for thirty-four years before retiring in June 2014. She especially enjoyed working as a class advisor for ten years. Throughout her career, she has continued taking courses and is a lifelong learner.

www.ingramcontent.com/pod-product-compliance
Lightning Source LLC
Chambersburg PA
CBHW060805100426
42813CB00004B/951